125 TREASURES

From the Collections of the National Trust

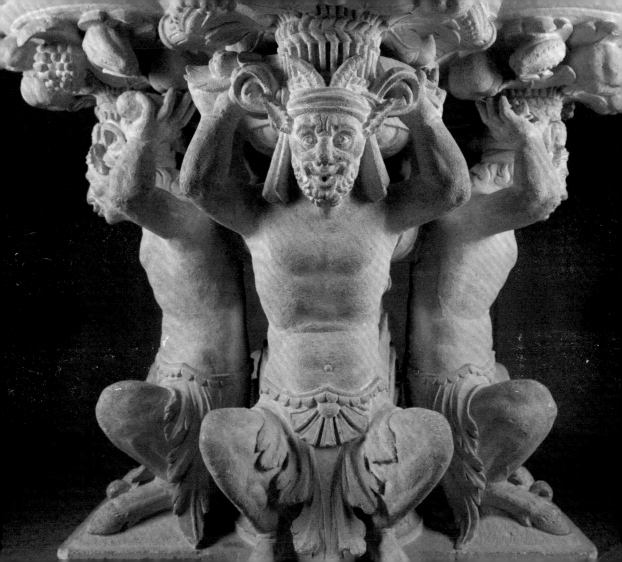

125 TREASURES

From the Collections of the National Trust

TARNYA COOPER

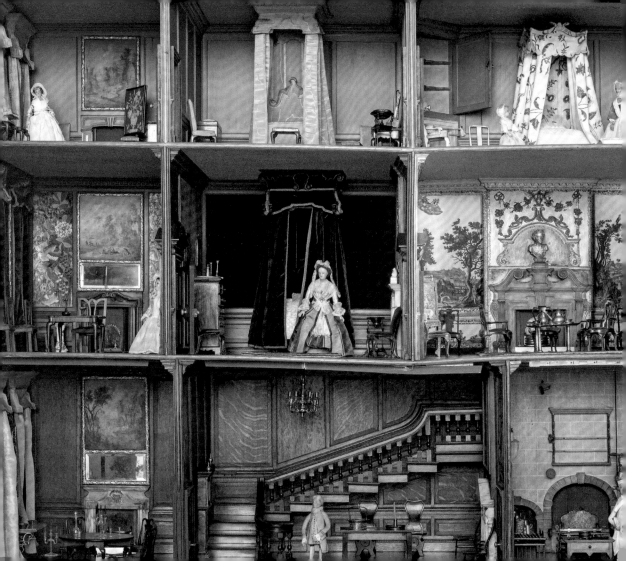

Contents

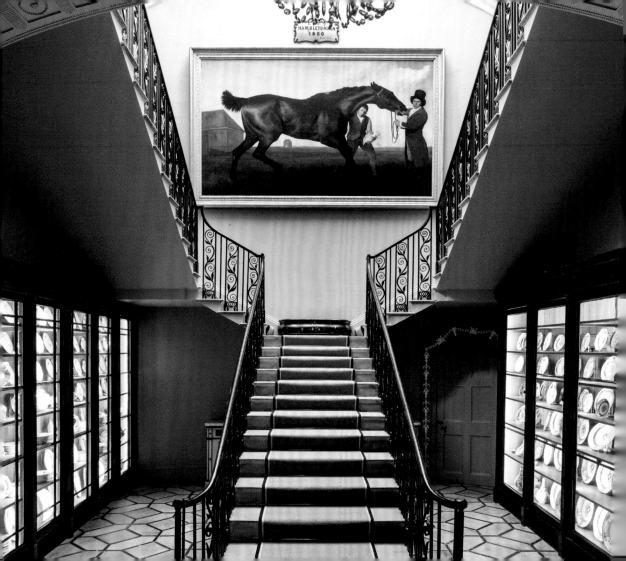

Foreword

I had my first encounter with the National Trust when I was 13. It was on a school trip to Mount Stewart in Northern Ireland. I vividly remember being awestruck by the grandeur and tiptoeing around the property, being so careful not to touch anything.

As we walked through the grand entrance hall, I looked up at an enormous picture hanging over the ornate polished staircase: *Hambletonian* by George Stubbs. I had literally never seen anything like it. Growing up on the outskirts of Belfast during the Troubles, real art was a rare thing. I loved art in all its forms, and I had seen *Hambletonian* in my textbooks.

Opposite · Hambletonian, Rubbing Down (1800), by George Stubbs, on display at Mount Stewart, County Down (see pages 148–9).

Frontispiece · Detail of the satyrs supporting the octagonal centre table (c.1542–53), traditionally attributed to John Chapman, at Lacock Abbey, Wiltshire (see pages 50–1).

Page 4 · Detail from the dolls' house (c.1729–42) at Nostell, West Yorkshire (see pages 110–11).

It was only when I was face to face with the painting that I fully appreciated its beauty – its depth of colour and the sheer size of it. Although I lost touch with the Trust for a few years after that, I never forgot the sight of *Hambletonian*, and it remains my favourite painting to this day. I'm just thrilled to see it take a place in this book as one of the selected treasures. I know it's been an almost impossible task to pick 125 from a collection of more than a million extraordinary objects, but I hope this book will give you a taste of the nature, beauty and history just waiting to be explored at National Trust places.

Every object tells a story, and we love nothing more than sharing these stories with people. Some of our pieces have enchanting and uplifting tales to tell, while others have profound and complex stories. All are important treasures in their own right. *Hambletonian* will always hold pride of place in our collections for me, and I hope this book will help you to find your own personal National Trust treasure.

Hilary McGrady,
Director-General of the National Trust

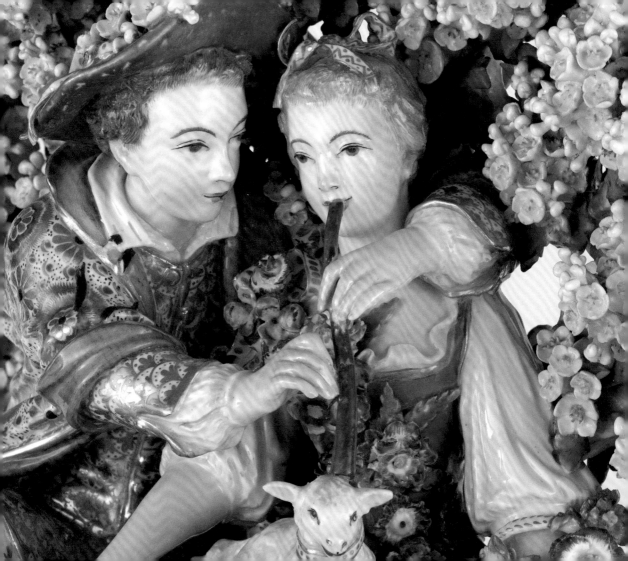

Introduction

Each of the 125 remarkable objects owned by the National Trust and showcased in this book has a particular story to tell. They were once part of collections treasured by former owners of significant historic houses, and their relevance derives from this association as well as from their importance as art objects. This book provides an opportunity to spotlight some of the most outstanding and internationally important works of art, furniture and books held in properties across England, Wales and Northern Ireland. The selection of objects ranges from ancient Greek sculpture to medieval Bibles, paintings and sculpture by some of Europe's most talented artists, along with tapestries, embroideries, costumes, silverware, ceramics and important decorative furniture.

Making this selection has been a particularly difficult task because the National Trust collections are both vast and astonishing. They are often presented in the historic environment for which they were created or acquired by past owners, and they remain an integral part of the history of each property. The greatest treasure

Opposite · Detail from the figure group *The Agreeable Lesson* (c.1765), modelled by Joseph Willems, at Upton House, Warwickshire (see page 120).

houses of the National Trust were usually built for and furnished by aristocrats, the gentry or wealthy industrialists, but today they are a fundamental part of the nation's heritage and open to everyone to discover, understand and enjoy. The quality of National Trust collections compares with those of the UK's national museums, and, for many of us, it is the surprising miscellany and variety of the displays that make visiting National Trust properties so fascinating, providing us with a visceral and often haunting sense of the past in the domestic setting. However, the individual stories of the objects also cast light on patterns in artistic creation at specific times and places across the world, revealing how they relate to other artworks and cultures quite distinct from those in their current home. Collectively, the National Trust interiors and collections provide an insight into the history of taste and consumption among some of the wealthiest and most influential households in England, Wales and Northern Ireland.

National Trust collections include objects that have influenced the course of history, such as the first atlas of England and Wales (see pages 62–3), which was used to plan Elizabethan defences. Other objects help us to recognise social changes that have affected us all, such as

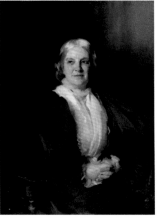
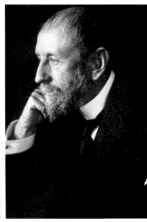

one of the earliest surviving sofas (pages 88–9), which introduced a new level of domestic comfort in the early 17th century. We can also chart global design trends, and see our colonial history through the personal stories of those who lived in the Trust's houses, such as European merchants in India who, in the 1760s, commissioned Anglo-Indian furniture from local craftspeople (pages 132–3). Or the couple in North Wales who decorated their bedroom with hand-painted Chinese wallpaper around the same time (pages 118–19). Or the investor and founder of the East India Company, who acquired a rare 17th-century Japanese rayskin chest (pages 70–1). And the many others who purchased Chinese porcelain (pages 48, 78–9 and 138–9), or furniture made of

mahogany harvested in the Caribbean by enslaved people (pages 124–5). The global histories – often extraordinary and occasionally challenging – that these objects reveal are firmly woven into the material culture of our national heritage.

The core purpose of the National Trust is to protect, care for, interpret and promote our national heritage – from landscapes to coastlines, from historic buildings with important regional and national significance to the collections they hold. Originally set up in 1895 by Octavia Hill

Above · The founders of the National Trust (left to right): Hardwicke Rawnsley (photographed by Olive Edis, *c.*1910), Octavia Hill (in a portrait of 1898 by John Singer Sargent) and Sir Robert Hunter (unknown photographer).

(1838–1912), Sir Robert Hunter (1844–1913) and Canon Hardwicke Rawnsley (1851–1920), we now care for more than 200 historic houses, numerous castles, industrial monuments and mills, chapels, lighthouses and barns, and a number of archaeological sites. From the 1920s the Trust began to acquire country houses to ensure their survival for the nation. However, this work accelerated in 1937 when, thanks to Philip Kerr, 11th Marquess of Lothian (1882–1940), the Country Houses Scheme was established, allowing owners to transfer their estates to the Trust in lieu of death duties. Many of the treasures featured here have been allocated to the National Trust through HM Government's hugely beneficial Acceptance in Lieu of inheritance tax scheme (see ‡ symbol).

The range and variety of our collections, and the fact they are displayed in historic, largely open domestic settings, mean they are particularly complex to look after. Over time, textiles, furniture and artworks tend to degrade and become vulnerable to wear, light damage and insect attack. Many of the objects in this book have had long and complex 'lives' before becoming part of National Trust interiors. They may, for example, have been transported from different countries and continents, been owned and used by multiple families and individuals over hundreds of years, been hung or displayed in unsuitable spaces, such as above hot and smoky fireplaces or in the bright glare of sunlight, been discarded and rediscovered in lofts or cellars, or separated from companion works or sets. And along the way they have sometimes been dislocated from their original stories – what inspired them, who designed and paid for them, and why. Consequently, it is often difficult to trace the provenance or past history of objects now held in National Trust houses. They were acquired not as museum objects that were carefully documented, but as family treasures, showpieces and curiosities, and the information about who made them, where and when they were acquired and on whose behalf is often lacking. The research for this publication has been undertaken by our expert curators and specialists (see page 222), who have direct knowledge of our collections and places across England, Wales and Northern Ireland, and their skill, insight and expertise are evident on every page of this book.

The collections found in National Trust properties were often acquired over many generations by families whose wealth, connections and opportunities to travel allowed them to commission successful artists and purchase objects from well-established collections, dealers and at auctions. The 16th-century tables at Lacock in Wiltshire and Hardwick in Derbyshire, for example (see pages 50–1 and 54–5) were purchased from, or directly influenced by, some of the most inventive French

Renaissance craftspeople. Other objects were acquired directly from archaeological excavations or purchased on trips abroad. Examples include the ancient Chinese tomb model of a camel (page 26), given to Agatha Christie (1890–1976) by her husband, the archaeologist Max Mallowan (1904–78), and displayed at their summer home, Greenway in Devon, and the 18th-century glass plates with views of Venice (page 113) that were brought back from Italy to The Vyne in Hampshire during the 18th century. Some objects were given as gifts to the original owners by friends and visitors, such as the Ethiopian shield that was offered as a mark of international friendship between His Majesty Haile Selassie I of Ethiopia (1892–1975) and Roger Grey, 10th Earl of Stamford (1896–1976), at Dunham Massey in Cheshire (page 199). Other objects, such as those apparently taken as spoils of war, have more difficult or complex histories to tell. This is the case with the beautiful and evocative cotton tent made for the Indian ruler Tīpū Sultān (1750–99). Taken following the Battle of Seringapatam and the death of Tīpū, it was acquired by Edward Clive, 1st Earl of Powis (1754–1839), when he was governor of Madras (pages 134–5).

The word 'treasure' is therefore a complicated one in the context of National Trust collections.

Right · Conservators working on the Japanese lacquer chest (*c.*1600) at Chirk Castle, Wrexham (see pages 70–1).

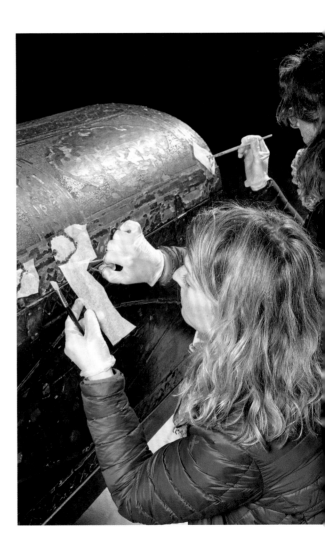

Not only will each of us have a different definition of what should be treasured and preserved but also some of the works featured in this book are, rightly, controversial 'treasures'. For objects, however amazing or beautiful, that were either taken or created to exert power over another culture or group of people, the word 'treasure' might be an inappropriate term. The argument for including such objects here is that the unique and varied narratives they present provide us with significant and meaningful insights into our complex national history and deserve to be better understood and debated. The interpretation of the historical context of any one object is always multifaceted and inevitably connected to individuals' particular personal, social and political viewpoints. And yet, as individuals, we can hold multiple and sometimes contradictory ideas about art objects simultaneously – such as admiration for craftsmanship or beauty, incomprehension about moral judgements made in the past, aesthetic pleasure, and curiosity about the meanings and juxtapositions within the context of a collection.

We were keen to represent a broad timespan, from the ancient world through to the 20th century, and to feature important collections from as many properties as possible. This book could easily have been five times as long and it is acknowledged that many important works of art are not included. The selection here should therefore be seen simply as a starting point for exploring the range and breadth of our art and decorative collections. Every choice here is personal, and it is worth noting that the strength of our collections would allow a different author at a different time to choose an almost completely different set of equally remarkable 'treasures'. Our aim is to pique your interest and inspire you to discover and learn more about the many other treasures in National Trust collections. To this end, we recommend our Collections website (www.nationaltrustcollections.org.uk).

This publication will be the first of several to explore the strengths, breadth and variety of our collections, and by buying this book you are helping us to raise much needed funds to conserve, research and present these collections as part of everyone's national heritage. I hope that the pleasure of looking through this book will inspire you to find your very own extraordinary objects among our impressive and often surprising collections.

Tarnya Cooper
Curation and Conservation Director, National Trust

Overleaf · Detail from a tapestry depicting Niobe's Pride (*c.*1590–*c.*1610) by François Spiering, at Knole, Kent (see pages 64–5).

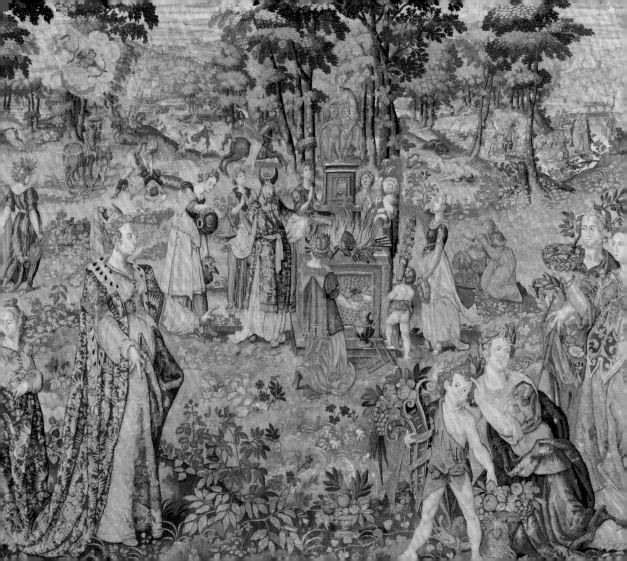

125 TREASURES

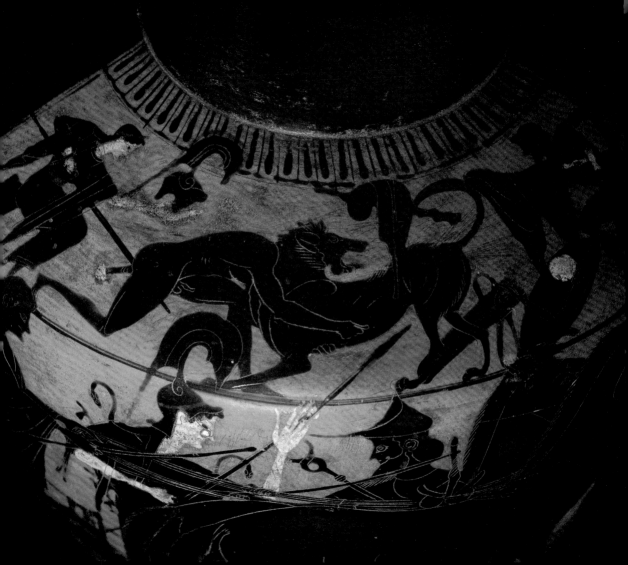

From Greek water vase to Italian tomb treasure

Decorated black-figure vases were a common feature in the homes of wealthy ancient Greeks. They survive in quite large numbers, but this example includes a particularly skilfully painted scene depicting a chariot with four horses, the goddess Athena and one of the labours of Heracles, a major Greek mythical hero. Many similar vases were exported to Italy, where they were considered high-status objects and buried as part of tomb treasure, probably as offerings to the gods or for use in the afterlife. This one may have been excavated from a grave in the Etruscan city of Vulci, which flourished prior to 200BC. It was probably acquired by the owner of Charlecote Park in Warwickshire, George Hammond Lucy (1789–1845), who was a keen collector of ancient art. It was displayed in his library to show the artistry and sophistication of the Greek civilisation.

Charlecote Park, Warwickshire · Hydria (three-handled pitcher) · *c.540–510BC* · *Black-figure technique, incised and painted in slip* · *42.5cm high* · *NT 532413*

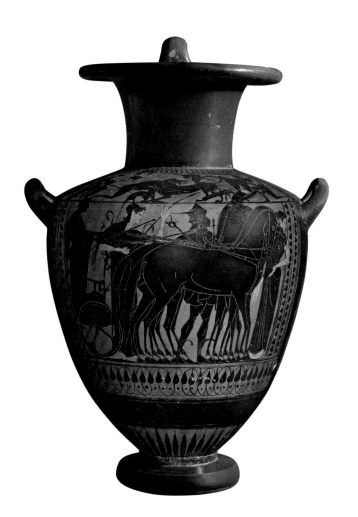

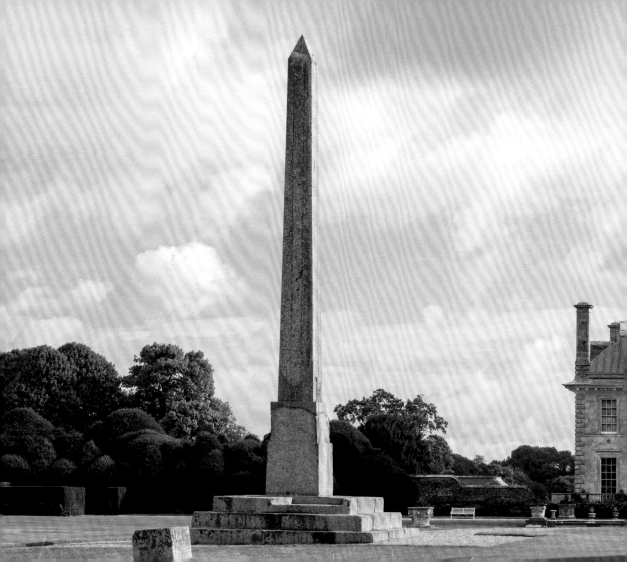

Code to the hieroglyphs

A 9-metre-high, pale pink ancient Egyptian obelisk stands today in a garden in Dorset. This important artefact was made some 150 years before the birth of Christ and was one of a pair that originally stood outside the Temple of Isis on the island of Philae in Aswan, southern Egypt. Its message is displayed in both ancient Greek and Egyptian hieroglyphic script, and may have been important to its earliest readers, as it communicated a revision to taxes. In the early 19th century, this inscription, along with the famous Rosetta Stone in the British Museum, became a critical aid to deciphering hieroglyphs.

The obelisk was brought back to Dorset by the explorer William John Bankes (1786–1855) and installed at his home at Kingston Lacy in 1827. A calamity occurred on its journey to England, when its vast weight caused a pier to collapse, and it slipped into the River Nile. Fortunately, it was rescued and came to the attention of the Duke of Wellington (1769–1852), who chose its location in the garden at Kingston Lacy and in 1827 laid the foundation stone.

Kingston Lacy, Dorset · 'Philae' obelisk · *150BC* · *Pink granite* · *900cm high* · *NT 1257614*

Mystery god of nature

This small, metal figure appears to date from around the 1st century AD, and although initially identified as the rarely depicted god Cernunnos, he is now considered to be an unknown deity. While the features of the figure are stylistically Celtic, it is most likely to be a Roman artefact. His oval eyes, hairstyle and moustache are clearly discernible, and he is shown holding an open-ended metal neck ring, known as a torc, with a small central indentation that may have once held a decorative inlay.

The figure probably originally served as the handle of a spatula, perhaps used to mix medicines, or wax to make writing tablets. It has been cast in a copper alloy and was found on the Wimpole estate in Cambridgeshire in 2018. It may have been lost or deposited here by inhabitants of early Roman Britain at the end of the Iron Age. It is a reminder of the ways in which the Celtic religion shared features with the Roman religion during the Roman occupation of Britain from AD43 to 410, when both worshipped multiple deities responsible for different aspects of daily life.

Wimpole, Cambridgeshire · Roman handle adornment · *1st century AD* · Copper alloy · *3.5 x 2.4 x 0.7cm* · NT 209384

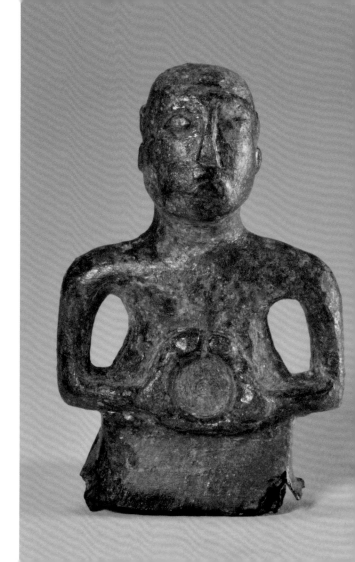

Echoes of laughter from the ancient past

This rare and extraordinary tomb carving celebrates the life of a Greek comic poet who died some 300 years before the birth of Christ. He carries an actor's mask and holds a scroll, which suggests he is a poet or performer. Although we don't know his name, he must have been widely celebrated to merit a gravestone commemorating his skills. This was not only the age of Socrates, Plato and Aristotle but also a time of regular conflict between Athens and its neighbouring city states. The poet's life may have been full of laughter and creativity, but he would almost certainly have served demanding and well-educated masters.

The grave relief was found outside Athens around 1812–13 and brought back to England by the explorer Thomas Legh (?1793–1857), who installed it (along with two others) in the remodelled library of his house at Lyme, Cheshire. It remains in situ today as a poignant reminder of both the power and importance of laughter and the connections between a lost civilisation and our own.

Lyme, Cheshire · Grave relief (or stele) of a comic poet · *Unknown artist · 400–340BC · Marble (large crystal) · 114 x 86cm (depth unknown as partly obscured within the fabric of the library) · NT 500255.1*

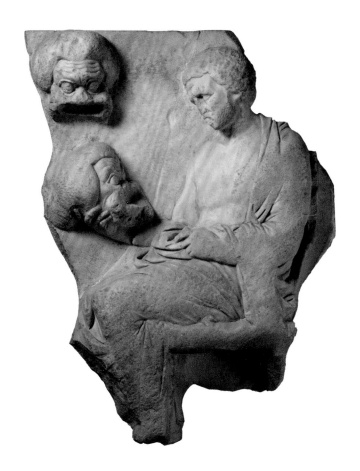

The face of a troubled boy and heir

This statue has recently been re-identified as a boyhood portrait of the much despised Emperor Nero (AD37–68). Nero came to power as a teenager, and his reign was notorious for tyranny, madness and cruelty, including the murder of his mother Agrippina and wife Poppaea, and the deliberate burning of Rome. Consequently, he was highly unpopular in his own lifetime, and many statues of Nero were defaced or destroyed following his suicide in AD68. This statue of him as a boy and heir is a remarkable survival and thought to be one of only three examples in existence depicting Nero in childhood. It was probably created to champion his claim to the throne, as he was adopted by the Emperor Claudius (10BC–AD54), who had a natural son and heir, Britannicus.

The sculpture was acquired by Charles Wyndham, 2nd Earl of Egremont (1710–63), in Italy in 1763 to add to his remarkable collection of antiquities.

Petworth, West Sussex · Emperor Nero as a Boy ·
*1st century AD with modern restorations · Carrara marble ·
136.5 x 68 x 39.5cm (base) · NT 486361 · ‡ 1956*

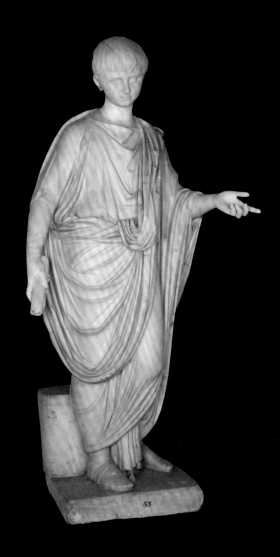

A rare Roman portrait found in Egypt

This striking life-sized bust of a commanding male head leaves us with some tantalising questions, but few answers. It was reportedly discovered near Alexandria in Egypt around 1780, and from the style we know that the sculptor was Greek or trained by a Greek artist in the centuries when Egypt was ruled by Rome. Opinion is divided about who it represents, but some think it depicts Mark Antony (83–30BC), a Roman general in charge of Rome's eastern provinces, including Egypt. Whoever the subject, it depicts a man of considerable importance and status, as the beautiful shiny black stone (known as basanite) was a rare material used only for individuals of the highest rank. His extremely long neck, square jaw and arched brows appear idealised, designed to flatter an important sitter. The sculpture came to Britain when it was acquired by the British representative to Egypt George Baldwin (1744–1826) and was later bought by the Egyptologist William John Bankes (1786–1855) for his impressive collection, which is still on display at Kingston Lacy, Dorset.

Kingston Lacy, Dorset · Portrait of a Roman (possibly Mark Antony) · *late 1st century BC–early 1st century AD* · *Basanite* · 75.5 x 26 x 20cm · *NT 1257603*

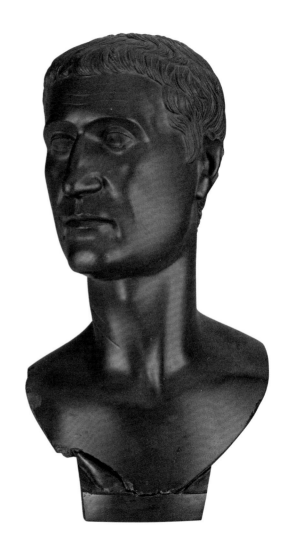

A cat to be purchased at a lavish cost

A cat has caught a snake and holds its head to the floor with one paw, but her attention is turned away to snarl at an approaching assailant, who is perhaps hoping to steal her prey. This remarkable sculpture is unique, and little is known about its history. It was purchased by Robert Clive of India (1725–74) during his grand tour in Rome and was considered to be an antique Roman sculpture. In 1774, Clive wrote to his wife Margaret, who loved cats, to tell her he had seen this 'antique Cat' and hoped to purchase it offering 'lavish' sums of money for her sake. The unknown sculptor shows extraordinary skill in crafting the hard, crystalline Greek marble into this naturalistic impression of a cat with her tail tucked beneath her body in fear.

The design for this sculpture could have been based on an original Greek composition, as depictions of cats are very rare in Roman art. The sculpture is difficult to date with certainty, and it has been suggested that it could have been made at a later date for the grand-tour market. However, recent research has indicated the sculpture is likely to be Roman.

Powis Castle, Powys · A Cat Playing with a Snake · *probably 1–200AD* · *Thasos marble* · *37 x 58 x 26cm* · NT 1180982 · ‡ 1963

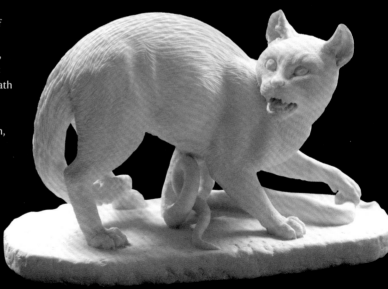

A ring of many faiths

Sometime in the 5th century, near the edge of the Roman town of Silchester (ruins north of Basingstoke, Hampshire), someone lost a valuable gold ring. The ring lay buried in the ground until 1785, when a farmer ploughing his field, perhaps catching a glint from the precious metal, recovered it and no doubt pondered upon its story. The size suggests it was made for a man's finger, and its multiple inscriptions can be linked to both the Roman religion and early Christianity, including the words 'Venus' (Roman goddess of love and victory) and 'Senicianus live in God'. At this time, pagan religions and Christianity existed side by side. Did the original owner use the ring to mark a conversion, or was he perhaps attempting to practise two faiths?

The ring was later acquired by the Chute family, who owned The Vyne, a Tudor mansion nearby. In the past it has been wrongly identified as the inspiration for J.R.R. Tolkien's *Lord of the Rings* trilogy.

The Vyne, Hampshire · The Ring of Senicianus · *Unknown maker* · *c.AD350–450* · *Gold* · *2.5cm diameter* · *12g* · NT 719789

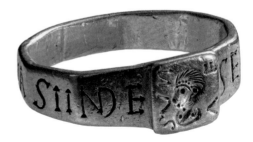

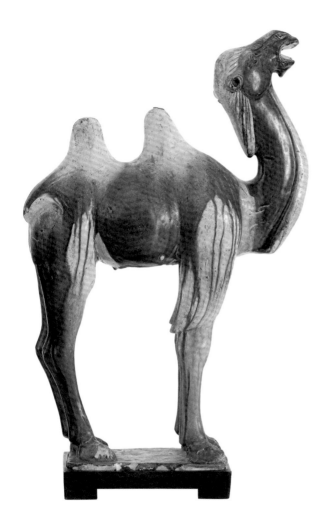

A gift to inspire a crime writer

This ancient Chinese tomb model of a camel was a gift from the archaeologist Max Mallowan (1904–78) to his wife, the crime writer Agatha Christie (1890–1976), and was displayed at their summer home, Greenway in Devon. The couple met when on an archaeological excavation in southern Iraq and married in 1930, and Christie continued to accompany her husband on excavations to Syria and Iraq.

The camel is one of many animal tomb monuments discovered in the late 19th and early 20th century in northern China, and dates from the Tang dynasty (618–907). Vast numbers of ceramic figures depicting whole households and their animals were originally installed in the tombs of royal and elite members of Tang society, and were known as *mingqi* (spirit goods).

Greenway, Devon · Model of a Bactrian camel · *c.700–756 · White earthenware, lead glaze, iron oxide · 57 x 38 x 16cm · NT 119162*

Page from the earliest known English Bible

This surviving fragment of text is an important document for the history of Anglo-Saxon Christianity. It was created in the 8th century at a monastery known as Wearmouth–Jarrow on the coast near Newcastle upon Tyne. This religious house, like those at Glastonbury, Malmesbury and Lindisfarne, was a centre for Christian learning and important in ensuring that Christianity took root in Britain. We know from one of the greatest scholars of the period, the Venerable Bede (673/4–735), who lived at Wearmouth–Jarrow, that the library contained books brought from Rome for reading and copying.

The monastery produced three enormous Bibles. Only one copy survives intact. The other two were broken up, probably in the 16th century. The surviving pages include those from the Book of Kings III–IV, now in the British Library. The page here (an extract from Ecclesiasticus) was found at Kingston Lacy, Dorset, in a set of estate papers from the 1580s.

Kingston Lacy, Dorset · Manuscript leaf from the Ceolfrith Bible, Ecclesiasticus 25:10–37:2 · *Unknown maker(s) in scriptorium of Wearmouth–Jarrow monastery* · *c.698–c.716* · Parchment · 42 x 33 x 0.1cm · NT 3174715

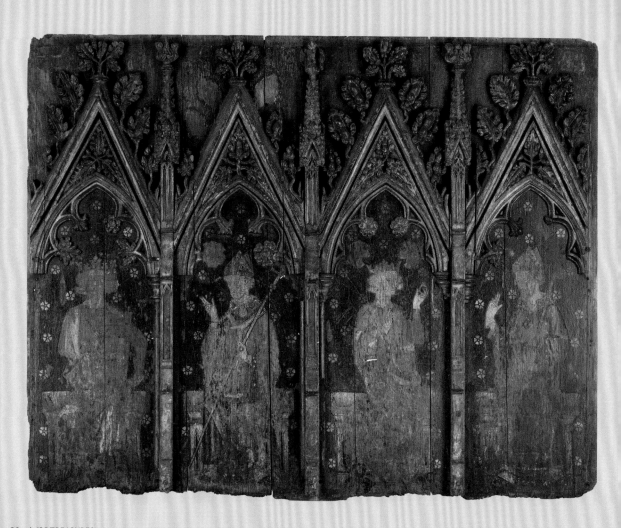

Devotion in Roman Catholic England

Before the Reformation in religion brought about by the Tudor monarchs Henry VIII, Edward VI and Elizabeth I, England was a Catholic country loyal to Rome. Numerous medieval churches would have had spectacular painted or carved rood screens dividing the nave of the church from the chancel or choir. The painted screen shown here is an English survival from the 1300s and depicts saintly kings and clerics. It was probably an object of devotion and prayer for thousands of Christians over several centuries.

The screen is rather damaged, and it is not known how it survived the Reformation or from which church it came. Most religious imagery was destroyed or whitewashed in the 16th century during state-sponsored removals and iconoclastic attacks. The screen appears to have been collected by the Bankes family of Kingston Lacy, Dorset, where it was found in the attic. It remains a remarkable legacy of English religious history.

Kingston Lacy, Dorset · Painted screen with St Edmund, an archbishop (possibly Thomas Becket), St Edward the Confessor and a mitred bishop · *Unknown maker* · *1300–15* · *Oak with polychrome and gilding* · *84.5 x 109.5cm* · *NT 1257255*

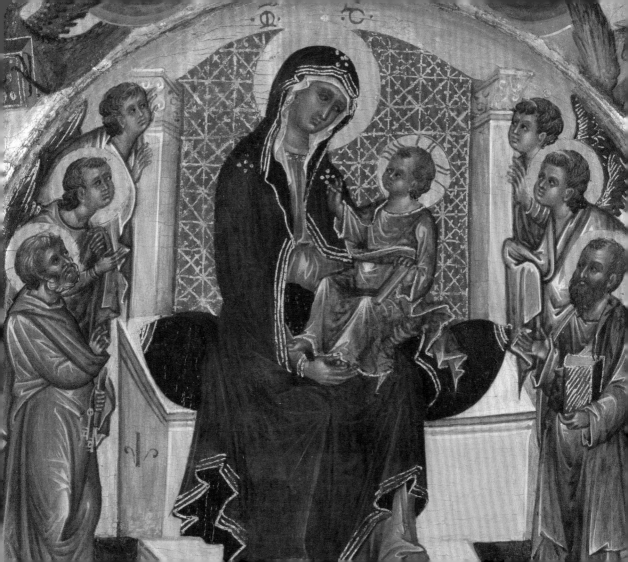

An aid to private prayer

This unusual, small-scale religious image of the Virgin and Child, Christ on the Cross and multiple saints was probably created as a devotional image. The painting style and format of the image unites two stylistic traditions – Italian and Byzantine. It is likely to have been made for a Venetian patron in the early 1300s by a painter trained in the artistic traditions of Constantinople (now Istanbul), as it includes features common in the Eastern Orthodox Church.

The range of saints depicted, not least the highly unusual St Louis of Toulouse (1274–97; the figure at the right in the bottom right-hand panel), would have been chosen by the patron and may have had particular significance to their personal circumstances. The canonisation of St Louis in 1317 has also helped to date the picture. The hinged 'wings' of the triptych were designed to close in order to protect the interior images when not in use for prayer and also made it portable.

Polesden Lacey, Surrey · The Virgin and Child Enthroned with Saints · *Italo-Byzantine School · c.1317–50 · Egg tempera and gold on panel · 39.4 x 27.9cm · NT 1246462*

A tool to understand the Bible

The nuns who were resident at the convent of Lacock Abbey in the 1300s would have had access to a significant library of religious manuscripts for prayer and study. This rare and remarkable surviving manuscript was part of that library and fortunately avoided destruction at the time of the dissolution of religious houses under King Henry VIII in the late 1530s.

The manuscript, which is effectively a dictionary of difficult words found in the Bible, was originally written in the 13th century by William Brito, and this version was copied by various scribes onto goat, sheep and calfskin. The manuscript was almost certainly produced at Lacock, and it clearly became a working reference tool for the convent as the binding appears to have once included a chain, ensuring the book remained in a particular place.

Lacock Abbey, Wiltshire · Expositiones Vocabulorum Biblie · *Guillelmus Brito, aka William Brito* · *c.1350?* · *Vellum, leather, wood* · *20.8 x 14.2 x 6cm* · *NT 3194532*

ubo clepo dco. e a
uult capo ee rotu
A scus q̃ ē rotudū
ē ali o g̃cm̄. eg̃
pelle capna. a pel
pellio forat ret. de
scutū cm coler ee
p̄cem tm̄ ymṅa.

Gole q̃ v
ec cap̄ la
tue.

A Renaissance air freshener

This beautifully decorated earthenware pot, dating from the 1400s, was designed to grow scented herbs, such as basil, which could help to mask any disagreeable odours in a room. These natural air fresheners would have been especially appreciated in enclosed spaces during hot weather.

Pots of this type decorated with lustre glazes were made in southern Spain, particularly the area around Valencia, and they were widely exported across southern Europe. The decoration could be commissioned to order and sometimes bore crests and coats of arms. On the pot shown here, the painted unicorn heads are part of a crest belonging to an unidentified Italian family. Although this type of ceramic pot would once have been quite common in wealthier homes, few survive today, and this example is the finest known to exist.

Waddesdon Manor, Buckinghamshire · Basil pot · *c.1440–c.1470 · Tin-glazed earthenware with metallic lustre · 34.2cm high x 39.5cm diameter · Waddesdon 10287 · ‡ 2016*

A medieval knight in a field of flowers

An encounter with this warrior-knight takes us on a journey back to medieval France. The knight, with his gleaming armour and red wolf or tiger flag held aloft, parades his elegantly decorated horse through a dense meadow of flowers. The design of this type of tapestry is described as *millefleurs* (a thousand flowers). The knight appears fearless and triumphant, the epitome of bravery depicted in French tales that were sometimes known as *chansons de geste* (epic poems or songs of heroic deeds).

The knight holds the coat of arms of Jean de Daillon, Seigneur de Laude or Lude (1413–81), who was governor of Dauphiné, a province in south-eastern France. Daillon commissioned the tapestry in 1477–9, but it was paid for by the town of Tournai as a gift. It was made in Tournai as part of a set by the master craftsman Guillaume Desremaulx (d.1482/3), but only this example survives. It is the earliest tapestry in the care of the National Trust.

Montacute House, Somerset · Tapestry depicting a knight with the arms of Jean de Daillon · *Guillaume Desremaulx* · *c.1477–80* · *Tapestry of wool and silk, 5–6 warp threads per cm* · *357 x 292cm* · *NT 598106* · *Bequeathed to Montacute by Sir Malcolm Stewart (1872–1951) in 1951*

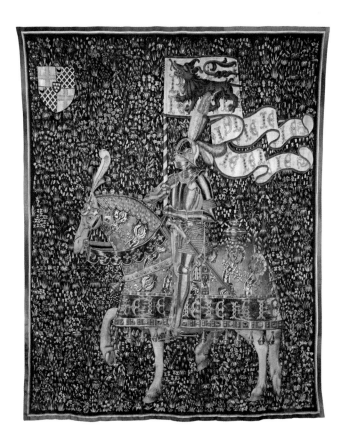

Lyme, Cheshire · Sarum Missal (Missale ad usum Sarum incipit feliciter) · *Guillaume Maynial and William Caxton* · *1487 · Ink on paper, calf-leather binding · 34 x 24 x 6cm · NT 3130883 · Acquired by private treaty in 2008 with the help of grants from the National Lottery Heritage Fund, the Foyle Foundation, the Pilgrim Trust, the Friends of the National Libraries, the Art Fund, the Robert Gavron Charitable Trust, the Royal Oak Foundation and private individuals*

From Roman Catholic to Protestant faith

Dating from 1487, this is one of the earliest printed books in the National Trust's collections. As a Roman Catholic prayer book, it provides a fascinating insight into religious practice in England before the Reformation and the establishment of the Protestant faith. Published by William Caxton (d.1492), England's first printer, it appears to have been printed in Paris to produce red and black type.

The book was probably acquired by Sir Piers Legh (1455–1527), the founder of the chantry chapel at Lyme in Cheshire, and was in use at the house at least from 1503 and possibly before. Its many hundreds of pages of Latin text show signs of use as an active working tool of religious life and practice. These include pen-and-ink annotations and additions to bring it up to date following the Reformation, and the removal of references to popes and martyrs, including Thomas Becket, by order of Henry VIII. The continued use of the Missal over centuries demonstrates how Christians adapted to religious change while retaining vestiges of past traditions. It remains an amazing survival, and the example at Lyme is the only known substantially complete copy in existence.

A clock without a dial

Few houses in Britain can claim to measure time by a 15th-century clock, but Cotehele House in Cornwall enjoys that distinction. This rare timepiece, found in the medieval chapel, began ticking at the start of the Tudor period (1485). It has no face, dial or hands and simply strikes the hour on a connected bell in the roof. Remarkably, it has survived unaltered for more than 500 years because, unlike most early clocks, it has not been converted to use a pendulum.

The design is a type of turret clock, so called because it was usually mounted high in a clock tower and consists of a wrought-iron frame and two trains of wheels. The clock has movable 40kg weights, one made of stone and the other iron, which help to adjust the timekeeping. The clock can run for 24 hours, but winding it requires considerable strength and agility. Until its restoration in the mid-20th century it had probably been left unwound – and silent – for centuries.

Cotehele House, Cornwall · Turret clock · *English maker* · *c.1490* · *Wrought iron mounted on oak* · *115cm high* · *NT 347888* · *‡ 1947*

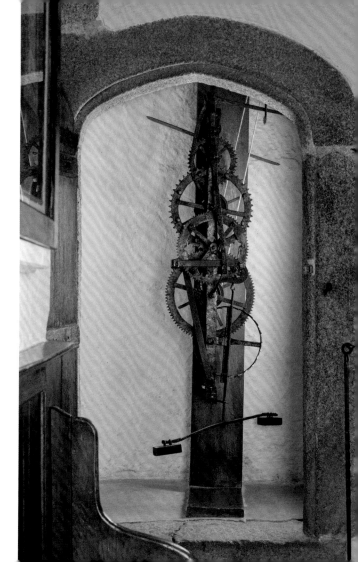

Recycled textiles from a medieval home

This (right) is one of three surviving fragments that are among some of the earliest English tapestries in the National Trust's collections. They date from the late 15th or early 16th century and were probably originally designed as part of a larger hanging, or possibly as cushion covers. The fearsome wild-boar heads with their sharp pointed tusks and a wreath of leaves were designed as part of family heraldry and can be associated with Sir Piers Edgcumbe (1468/9–1539), who inherited the beautiful estate of Cotehele in Cornwall in 1489. He may have commissioned the tapestries from an English workshop, and they are very rare examples of English heraldic textiles.

The tapestries were adapted, or perhaps rescued, in the 18th century, and three fragments were sewn into later Dutch or Flemish tapestries depicting fruit and flowers. This reuse indicates their importance in telling the history of the family dynasty and ensured the survival of these textiles.

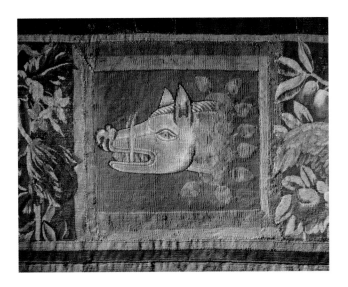

Cotehele House, Cornwall · Boars' Heads tapestry fragments · *c.1489–1700 · Wool and silk, 5½–7 warp threads per cm · 56 x 302.5cm and 30 x 163cm · NT 348249 · ‡ 1974*

The printed book and a thirst for knowledge

When this volume was first published in 1493, few people had held an illustrated printed book in their hands. A richly illustrated secular work, it was published in both Latin and German in Nuremberg and subsequently became known in English as *The Nuremberg Chronicle*. The book has enormous significance as it helped to create a demand for information about the known world and an appetite for reading the printed word.

The pages of this book document the known cities in Europe and the Middle East, including Jerusalem, and provide a history of the world. This page (opposite) shows a chilling 'dance of death', a common scene reflecting on human mortality. The author, Hartmann Schedel (1440–1514), was a scholar and physician, and employed two printmakers – Michael Wolgemut (c.1434/37–1519) and Wilhelm Pleydenwurff (c.1458–94) – to create the lively printed images.

This copy, from Saltram in Devon, was once held in the monastery of St Emmeram in Regensburg, Germany.

Saltram House, Devon · The Nuremberg Chronicle (Liber Chronicarum) · *Hartmann Schedel · 1493 · Ink and paper, pigskin over wooden boards · 49 x 33 x 11cm · NT 3069418 · ‡ 1957*

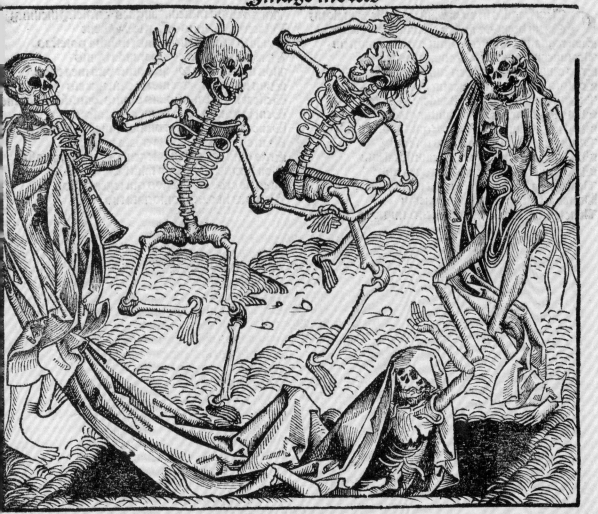

Orte nihil melius. vita nil peius iniqua

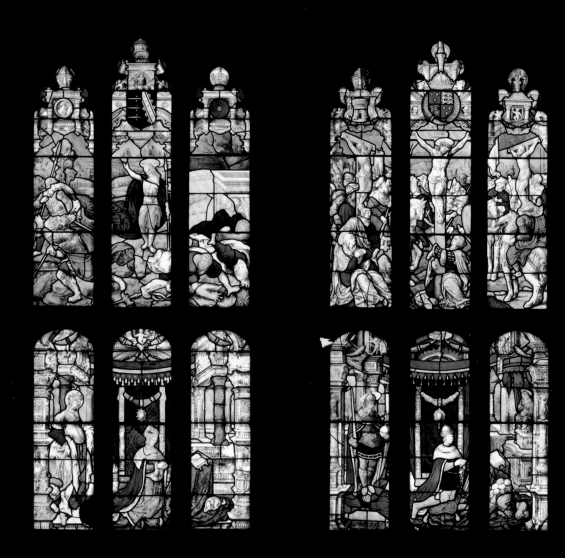

Homage to a charismatic king

This exceptional scheme of early 16th-century stained glass was commissioned sometime before 1533 by William, 1st Baron Sandys (c.1470–1540), who served as Lord Chamberlain to King Henry VIII (1491–1547). It was probably designed for the chapel of The Vyne, his house in Hampshire, where it can be seen to this day. The scheme included scenes from the life of Christ and (unusually) three royal portraits – a young Henry VIII, his first wife Catherine of Aragon (1485–1536), and his sister Margaret Tudor, Queen of Scots (1489–1541), together with their patron saints. Sandys could never have known how quickly the design would become outdated: following the annulment of the king's marriage to Catherine, the monarch famously went on to have five further marriages.

The quality and craftsmanship of the glass panels are among the best in Europe, and for a long time they were thought to have been designed by a talented émigré artist. However, recent research has indicated that they were, in fact, crafted by numerous different glaziers, a common practice when a large commission had to be fulfilled.

The Vyne, Hampshire · Eighteen stained-glass panels · *Unknown makers · Early 16th century · 147–195 x 46cm · NT 719818*

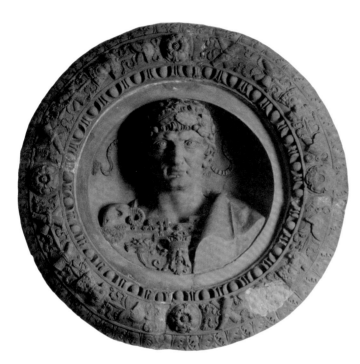

Italian Renaissance brilliance in England

This striking terracotta roundel appears to have been produced in England by an Italian Renaissance artist working in the reign of Henry VIII (1491–1547). At first sight, the evident technical skill and dramatic stylisation would have amazed and impressed English audiences. The roundel may have been commissioned or acquired by Henry VIII's Lord Chamberlain and trusted adviser, William Sandys, 1st Baron Sandys (c.1470–1540) for his Tudor mansion known as The Vyne. It was probably produced by the studio of the Tuscan artist Giovanni da Maiano (c.1486–c.1542), who came to work in England around 1521. Along with Baron Sandys, he had a role in preparations for the production of celebratory buildings that were erected for the meeting between the French king François I and Henry VIII, known as the 'Field of the Cloth of Gold', in 1520.

The bearded figure was once thought to be the Roman Emperor Probus (d.AD282), who may have introduced grapevines to Britain. However, the figure does not resemble known representations of Probus and is more likely to depict another Roman worthy. Giovanni da Maiano was also commissioned by Cardinal Wolsey to produce eight medallions of Roman heroes of a similar design for Hampton Court.

The Vyne, Hampshire · Portrait roundel of a classical male figure · *Studio of Giovanni da Maiano* · *c.1520–1* · *Terracotta* · *89cm diameter* · *NT 719614* · *Bequeathed with The Vyne estate and contents by Sir Charles Chute, 1st Bt*

A cardinal's silk and silver purse

This stylish leather and silk purse decorated with silver thread dates from the early 16th century. It probably once belonged to Cardinal Thomas Wolsey (1470/1–1530), one of the most important and powerful men at the court of King Henry VIII. Wolsey served as Lord Chancellor and was the closest of the king's advisers, but he fell out of favour and was accused of treason. Perhaps fortunately, he died before he could face charges.

Purses like the one shown here would have been used not just for coins but also to store other precious personal items, such as gaming pieces, keys, seal rings and documents. They were usually attached to a girdle or belt with leather loops (hence the term 'cutpurses' to describe thieves or pick pockets) but fell out of fashion when pockets in clothes became more common later in the century. This purse includes typically Roman Catholic imagery on the front – a crucifix and chalice. The inner clasp bears Wolsey's name and non-standard Latin numerals perhaps for the date 1518, when he was at the height of his political powers.

Seaton Delaval Hall, Northumberland · *Purse · Unknown maker, probably English · First half of the 16th century · Leather, metal thread, silk satin and silver · 15 x 21cm · Inscribed on clasp: 'Cardinalis Ts. Wolse IVXVIII' and 'Fidei coticula crux' [The cross is the touchstone of faith] · NT 1276904 · ‡ 2011*

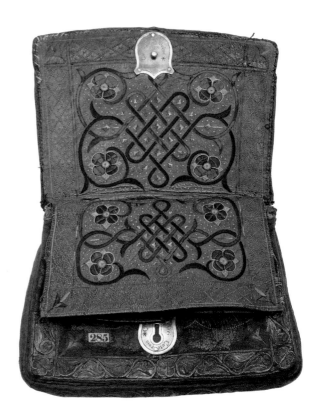

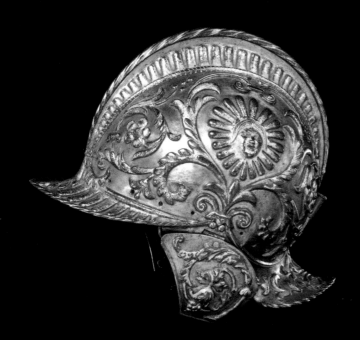

A helmet fit for an emperor

Gleaming pieces of armour adorn the walls of many National Trust properties, a legacy of the role that landed families played in supporting regional and national defences. The helmet shown here, however, had a different purpose and is particularly special because it was made for Charles V (1500–58), the Holy Roman Emperor, in 1534. It was purchased in 1892 by Alice de Rothschild (1847–1922) to be displayed as a star item in the armour collection at Waddesdon Manor, which furnished the guest Bachelor's Wing of the house.

The maker of this impressive helmet (known as a burgonet) was the Italian armourer Caremolo Modrone (*c.*1489–1543), who worked in Mantua. The helmet is both showy and glamorous, intended as parade armour rather than for use in battle. The steel was heated to produce a distinctive blueish-purple colour, allowing the gilded embossed decoration to glow. The Emperor was delighted with his Italian amour and is reported to have praised the perfect fit.

Waddesdon Manor, Buckinghamshire · Parade helmet · *Caremolo Modrone* · *c.1534* · *Gilded steel and wood* · *24.5 x 31.5 x 18cm* · *Waddesdon 3461*

A German merchant in Tudor London

On the streets of Tudor London citizens would have encountered men and women from many different parts of Europe and beyond. They came to London as religious émigrés and as skilled merchants, professionals and artisans. This portrait probably depicts a German merchant of the London steelyard, one of several merchants painted in 1533 by the artist Hans Holbein the Younger (1497/8–1543).

The young man is dressed in clothes appropriate for a merchant – a black cap, cloak and red tunic. He faces slightly to his right and looks thoughtfully into the distance. It is possible that the flower (known as a 'pink') he holds in his hand alludes to an engagement. This small-scale picture painted on a wooden board would have been easy to transport or send home to a loved one.

Upton House, Warwickshire (The Bearsted Collection) ·
A Young Man with a Pink · *Hans Holbein the Younger · 1533 ·*
Oil on oak panel · 12.5cm diameter · NT 446801

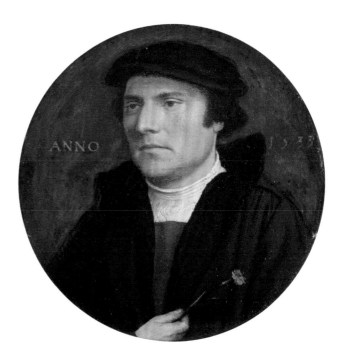

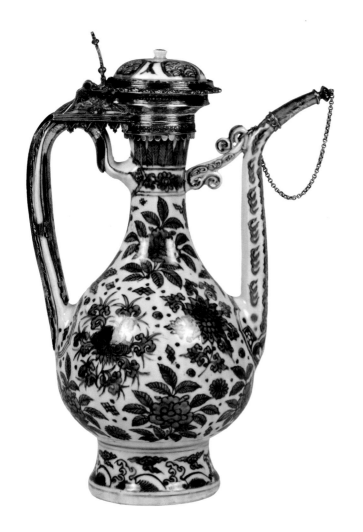

Keeping your hands clean

By the 16th century, well before European craftspeople had learnt to manufacture hard white porcelain ware, Chinese porcelain was imported into Europe in significant quantities, often as part of a prized display of banqueting tableware. Jugs or ewers like this one were used in wealthy European households to hold scented rosewater for washing the hands between courses. This was a high-status ritual, and a useful one, as people often ate with their fingers.

The shape of this ewer has been adopted from earlier gold vessels made in 15th-century China to hold wine for the imperial family during the Ming dynasty (1368–1644). The porcelain versions were decorated in blue and white, usually with naturalistic floral motifs as seen here. This example has been embellished with silver-gilt additions made in London, which were designed to make it easier to handle and to enhance its value. It is not known how this ewer came to Hardwick Hall in Derbyshire, since it does not seem to appear in the 1601 inventory of the possessions of Elizabeth Talbot, Countess of Shrewsbury (?1527–1608).

Hardwick Hall, Derbyshire · Ewer · *Unknown workshop and kiln in Jingdezhen, China, c.1550–70; England, 1589–90 · Blue and white porcelain with English silver-gilt mounts · 35.5cm high · NT 1127144 · ‡ 1958*

Renaissance plates as paintings

At the height of the Italian Renaissance, exceptional-quality ceramics were produced to be displayed as examples of high art, rather like paintings. The whole surface of this dish is treated as a picture and depicts a battle scene between the Romans and the Samnites, a story from *The History of Rome* by Titus Livius (Livy, 59BC–AD17). The composition creates a dizzying sense of the heat of the battle: spears are wielded with terrifying vigour, horses trample on fallen assailants, and a victorious banner representing Rome is held aloft.

This particularly high-status, tin-glazed earthenware dish is an example of a type known as maiolica. It was made in the workshop of Guido di Benedetto Merlino (active 1523–58), a master potter based in Urbino. He employed numerous artists to depict Roman histories, mythologies and religious images known as *istoriati* (story paintings).

Knightshayes Court, Devon · Painted dish depicting a battle between the Romans and the Samnites · *Workshop of Guido di Benedetto Merlino · c.1545 · Tin-glazed earthenware decorated in colours · 47cm diameter · NT 540387*

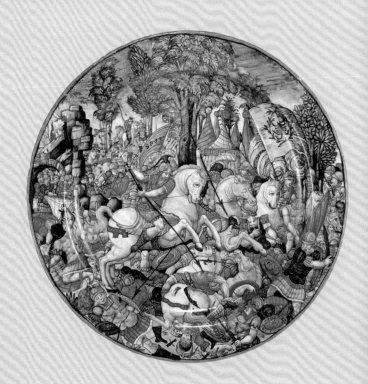

An extraordinary, fantastical table

Installed at Lacock Abbey between 1542 and 1553, this unusual octagonal stone table was commissioned by Sir William Sharington (*c*.1495–1553) for a small room within an octagonal stone tower, probably designed to safeguard his treasured collections and curiosities. Sharington purchased Lacock Abbey – formerly a nunnery – in 1539 following Henry VIII's order for the dissolution of religious houses. He remodelled the building extensively, and this table includes his carved monogrammed initials along with those of his wife Grace Paget, née Farrington (*fl.c*.1520–56), whom he married in 1542.

The design of the table is extraordinary. It is supported by four crouching satyrs (creatures with men's bodies and goats' legs) holding baskets of fruit upon their heads. It is possible that Sharington supplied printed designs to guide the stonemason, and the creatures bear some similarity to crouching satyrs in the work of the French designer Jacques Androuet du Cerceau (*c*.1520–86). Like the sea dog table at Hardwick Hall, Derbyshire (see pages 54–5), it provides a glimpse of the inventive style of fashionable Tudor interiors, which were influenced by Italian and French Renaissance ornamental designs.

Lacock Abbey, Wiltshire · A centre table · *Traditionally attributed to John Chapman (active c.1550)* · *c.1542–53* · *Purbeck marble and oolitic limestone* · *91.5 x 106 x 106cm* · *NT 996422*

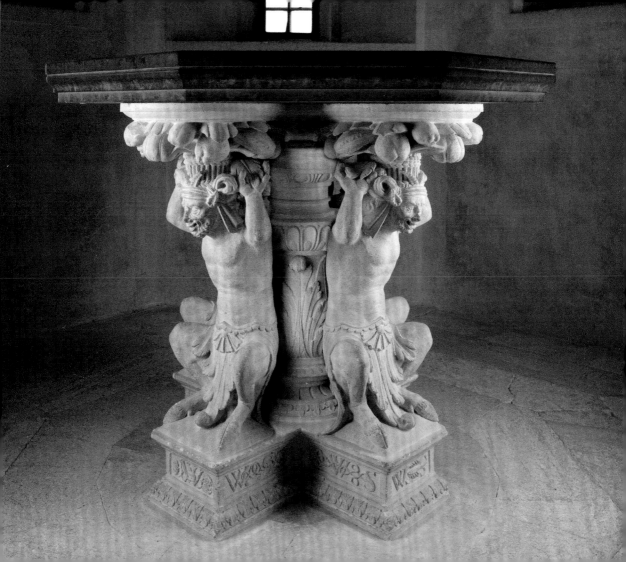

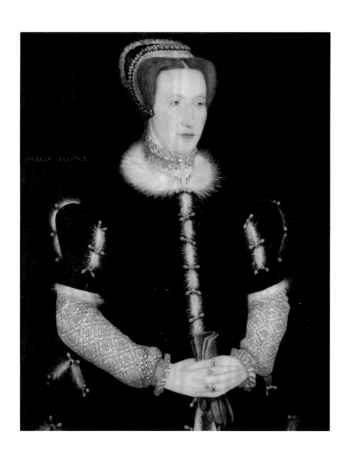

The face of female ambition, ingenuity and power

Elizabeth Talbot, Countess of Shrewsbury (?1527–1608) – better known as Bess of Hardwick – was widowed four times and died one of the richest women in England. She served Queen Elizabeth I (1533–1603) as a gentlewoman of the chamber and proved loyal, remarkably resilient and energetic. She was not only active in promoting her family interests but also developed a passion as a patron of the arts. Her finest achievement remains perhaps one of the most beautiful houses in England: Hardwick Hall in Derbyshire, which still has multiple copies of her initials 'ES' standing proudly on the roof. Few other women of this time had such a legacy or claimed such influence.

This portrait shows her when married to William St Loe (c.1520–65), Captain of the Queen's Guard, who left her a considerable fortune on his death. She appears finely dressed in a fur-lined gown and gemstone rings. Characteristically, the portrait shows both her strength of character and high status because she appears facing towards the viewer's right, a placing more traditionally reserved for men.

Hardwick Hall, Derbyshire · Elizabeth Talbot, Countess of Shrewsbury · *Follower of Hans Eworth* · c.1560 · *Oil on panel* · 87.6 x 66.7cm · *Incorrectly inscribed centre left 'MARIA REGINA' [Queen Mary]* · NT 1129165 · ‡ 1958

Punning dolphins

Carved wooden beasts like these were originally designed to sit on top of armoured helmets worn at ceremonial events and court contests. However, these dolphins were probably used on helmets prominently displayed at the funerals of members of the Godolphin family. The dolphin emblem was chosen as a pun on the family name and also alluded to the fact that they owned large stretches of the Cornish coast. The earliest crest is similar to those worn at court jousts in front of Queen Elizabeth I and appears to have belonged to Sir William Godolphin (c.1518–70), who served the Crown in various offices.

As recognisable heraldic symbols, such crests could convey association with landed families across time. These emblems appeared in seal rings (used to seal correspondence), as well as on servant livery, horses and coaches, and were often carved or engraved onto architectural features.

Godolphin House, Cornwall · Heraldic helmet crests · *Unknown maker · c.1570? and 1600s · Wood with polychrome and gilding · 22 x 35 x 7cm and 18 x 33 x 9cm · NT 169408 and 169409*

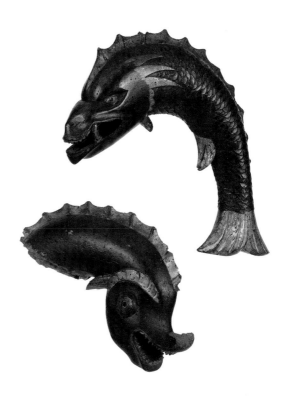

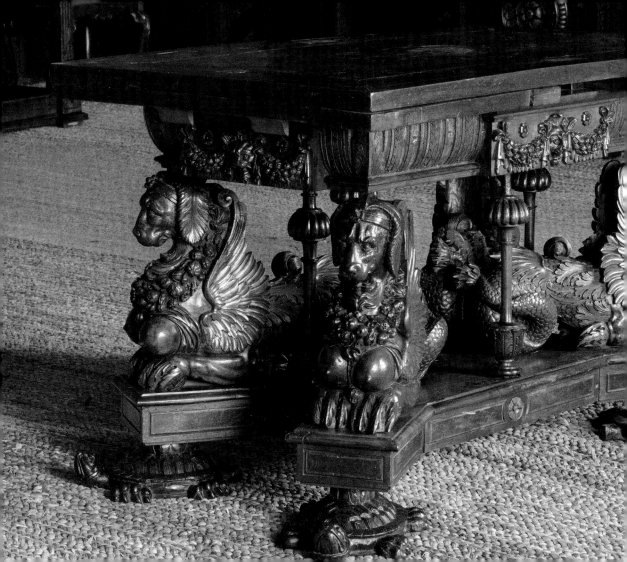

A 'sea dog' monster table

Elaborate, fantastical and exquisitely carved, this eye-catching table is one of the best surviving examples of Elizabethan furniture in the National Trust collections. It was commissioned from one of Europe's top craftspeople working in Paris. The highly unusual design features four carved 'sea dogs' – fantasy creatures with a dog's head, scaly breasts, wings and dolphin tails. It was purchased for display at Chatsworth House in Derbyshire, the home of George Talbot (c.1522–90), 6th Earl of Shrewsbury, and his wife Elizabeth (known as Bess of Hardwick; see page 52) in the 1570s.

The quality of the piece, the striking design of the sea dogs and the Italian marble inlay would have made it a talking point for the couple's visitors. The earl had responsibility for Mary Queen of Scots, who was under house arrest in his home, so this table would almost certainly have been known and admired by her. After the marriage ended c.1584, Bess took the coveted table and it later furnished her new home, Hardwick Hall in Derbyshire, where it remains.

Hardwick Hall, Derbyshire · Sea dog table · *After Jacques Androuet du Cerceau · c.1570 · Walnut with gilding, fruitwood and tulipwood marquetry top with marble inlay · 85 x 147 x 85cm · NT 1127744 · ‡ 1958*

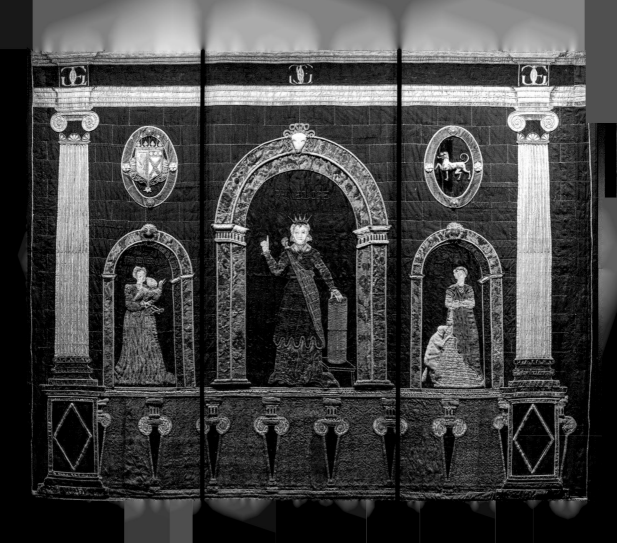

Elizabethan heroines

During the 16th century, the nobility and gentry commonly used embroidered wall hangings and tapestries to decorate their houses. The elaborate hanging shown here is one of the largest and most significant to survive from the Elizabethan period, and was commissioned by Elizabeth Talbot, Countess of Shrewsbury (see page 52) for her house at Chatsworth in Derbyshire. It is one of a set of five showing biblical and mythical female figures – Lucretia, Zenobia, Artemisia, Cleopatra and, in this case, Penelope, wife of the classical hero Ulysses, who spent ten years away at the Trojan war. She is celebrated at the centre of this embroidery, and personifications of the virtues of patience and perseverance are shown at either side.

The embroidery includes the countess's coat of arms alongside that of her fourth husband George Talbot, 6th Earl of Shrewsbury (c.1522–90). The couple's marriage ended acrimoniously, and the hangings became the subject of legal disputes between husband and wife in 1585 and 1586. This was resolved in the countess's favour, and they appear in an inventory of her goods at her new home – Hardwick Hall – in 1601.

Hardwick Hall, Derbyshire · Wall hanging: Penelope flanked by Perseverance and Patience · *c.1573* · *Silk, cloth of gold and silver; linen backing* · 278 x 350cm · NT 1129593.1 · ‡1984

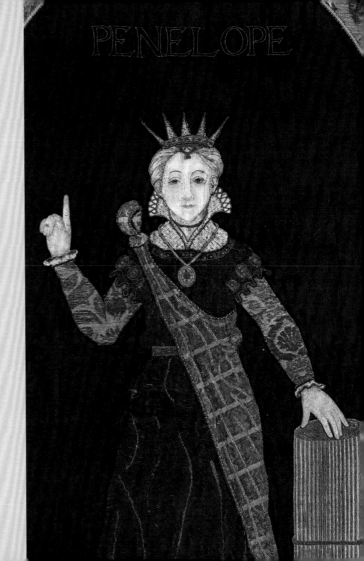

The craft and art of bookbinding

The craft of bookbinding became an art in itself during the European Renaissance as the ownership of well-stocked libraries became ever more important to the status and influence of courtiers, statesmen and the nobility. The ornate binding shown here was commissioned for the library of the Elizabethan politician Sir Nicholas Bacon (1510–79). He served as Lord Keeper of the Great Seal, and this beautiful binding in calfskin and goatskin includes his painted coat of arms.

In Britain, the best examples of bookbinding were produced or influenced by European craftspeople. This one is the work of the émigré Huguenot bookbinder Jean de Planche, who worked in London from 1567 to at least 1575. His skills were greatly prized, and his clients included Queen Elizabeth I and the Archbishop of Canterbury. The binding shown here was made to contain an enormous encyclopedia of human and divine knowledge by the Swiss scholar Theodorus Zwinger (1533–88).

Kingston Lacy, Dorset · Binding for 'Theatrum vitae humanae' · *Jean de Planche* · *Basel* · *1565* · *Couch-laminated paper boards (millboard), calfskin, goatskin, paper, gold leaf, pigments* · *NT 3095989*

A pope's secret cabinet

One of the most magnificent and elaborate items of furniture in the National Trust's collections, this cabinet was once owned by Felice Peretti, Pope Sixtus V (b.1521; r.1585–90). Inside are 153 separate drawers for keeping secret items and precious personal collections, such as miniatures. The cabinet was designed to amaze and impress, so it was made with a range of rich materials, including gilt bronze, ebony, alabaster and a vast number of different hardstones, semi-precious materials and jewels, such as crystal, garnet, jasper, lapis lazuli, amethyst and mother-of-pearl. The exuberance of the design, which is modelled like a church façade, was characteristic of baroque papal taste, and it was probably commissioned by the pope c.1585 for display at his private palace in Rome.

The cabinet was sold around 1740 by a Roman convent and purchased by the banker Henry Hoare II (1705–85) during a grand tour and displayed at his house at Stourhead in Wiltshire.

Stourhead, Wiltshire · The Pope's Cabinet · *Roman workshop* · *c.1585* · *Plinth probably designed by Henry Flitcroft (1697–1769) or John Michael Rysbrack (1694–1770) and made c.1742–3 by 'Mr James', with carvings by John Boson (c.1696–1743)* · *Cabinet: ebony mounted in gilt bronze and pietre dure* · *210 x 130 x 64cm* · *NT 731575* · *Plinth: oak carcass veneered with mahogany, partly carved and gilded* · *108 x 134 x 90cm* · *NT 731575*

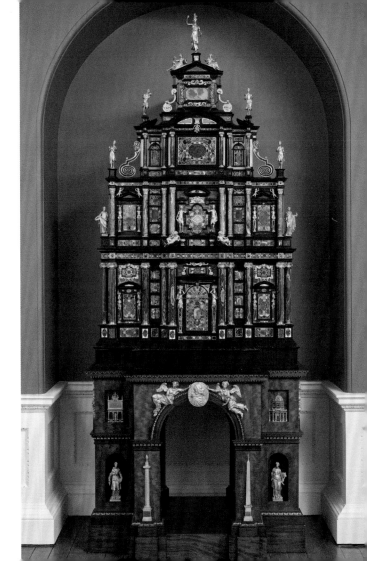

Form over function?

This rare and high-status feature table was purchased for Powis Castle in Wales and must have inspired awe and wonder. It is made of precious decorative stones set into an inventive design depicting birds, insects, flowers and foliage, and was produced in Italy around 1580. The table was never meant for dining, and not all visitors shared the host's passion for this ornate piece of furniture. In the 1790s one guest commented that the sale of this Roman table could pay for 'the purchase of a good English dining table'.

The stones used for the tabletop were particularly valuable in their own right, and some may even derive from ancient archaeological sources, such as the Baths of Caracalla in Rome, which were excavated in the 1540s. By tradition, this table is said to have come from the Borghese Palace. It may have been acquired in Italy by George Herbert, 2nd Earl of Powis (1755–1801), during his grand tour of Italy.

Powis Castle, Powys · *Pietre dure table · Rome (top), Italy or France (base) · c.1580 · Inlaid hardstone surface, giltwood and painted base · 92 x 257 x 134cm · NT 1181054 · ‡ 1992*

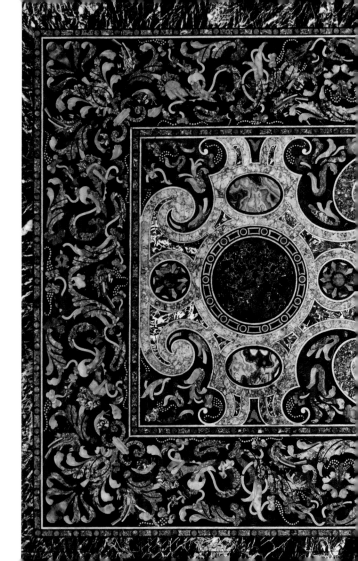

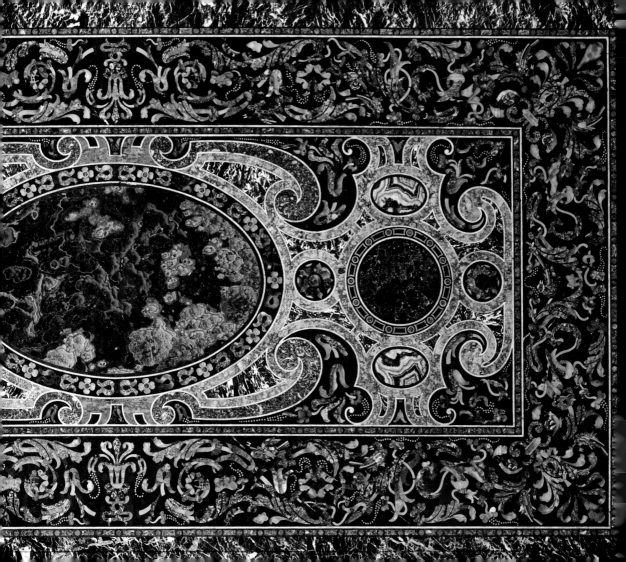

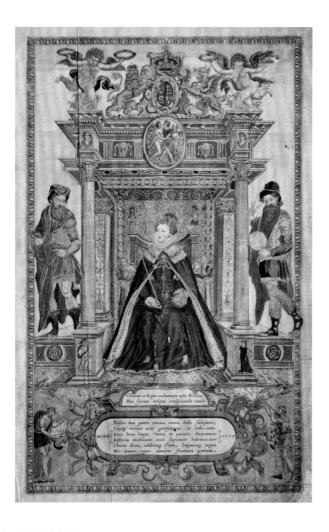

An atlas ordered by a queen

The cartographer Christopher Saxton (c.1540–c.1610) spent years surveying the counties of England and Wales to produce the first national atlas in 1579. Saxton was supported by Queen Elizabeth I, whose portrait appears on the frontispiece, and the courtier Thomas Seckford (1515/16–87), whose coat of arms appears on each map. Accurate maps were of critical importance at a time when the country feared foreign invasion from Roman Catholic Spain, and Saxton was given every assistance with the process of surveying, and the work was quickly published.

The carefully drawn engravings were undertaken by an émigré team of Netherlandish engravers, several with experience in European cartography. It is an extraordinary testament to the accuracy of Saxton's maps that they continued be used and revised until 1801, when the Ordnance Survey began publishing its 'one-inch' series of maps. The atlas went through numerous revisions, and this version dates to 1590, when the index was revised.

Anglesey Abbey, Cambridgeshire · Atlas of the Counties of England and Wales · *Christopher Saxton · c.1590 · Tanned calfskin leather, gold leaf, board, paper, printing ink and hand colouring · 43.1 x 31.8 x 3.4cm · NT 3070746*

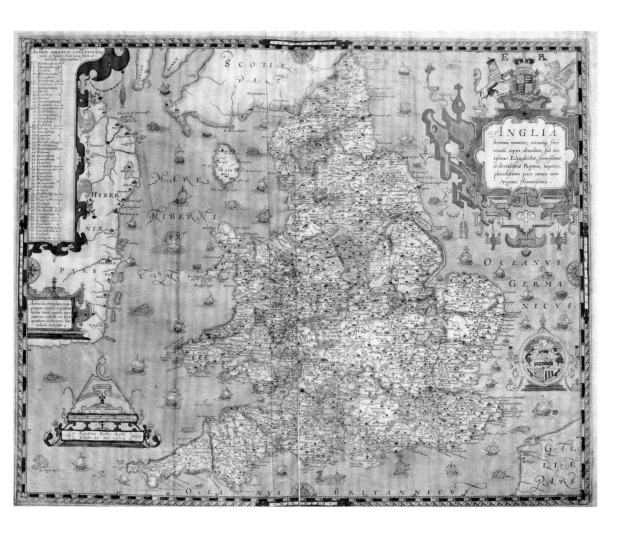

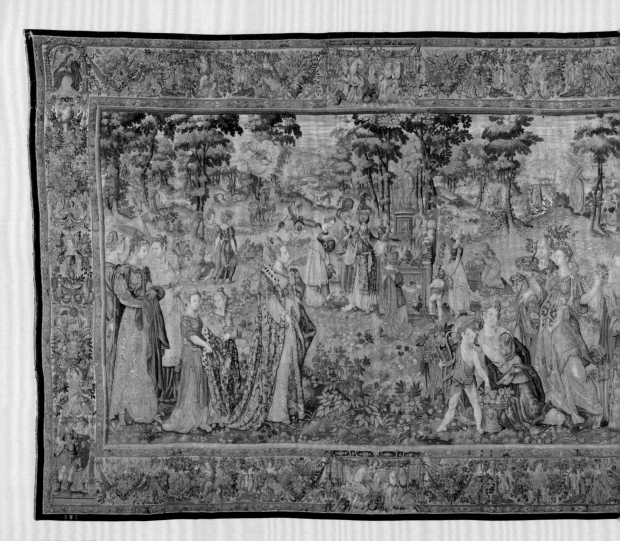

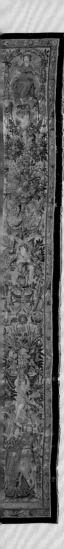

Repurposing a king's textiles

This tapestry was originally one of a set of six depicting scenes from the life of Diana, the Roman goddess of the hunt, and was once owned by King James VI and I (1566–1625) as a key part of a fashionable interior at a royal palace. However, it is not known if the set was ever used by the king. In 1620 the tapestry set was purchased from the Crown by Lionel Cranfield, 1st Earl of Middlesex (1575–1645), for the sum of £257.12s (the equivalent of around £35,000 today). Cranfield had made his fortune as a successful textile merchant and went on to become Lord Treasurer in 1621. He purchased these prestigious tapestries for his redesigned London house in Chelsea, where they were displayed in the 'Withdrawing Chamber', which was furnished with red velvet chairs and stools.

His enjoyment of his new house was short-lived, however, and by 1624 he was accused of corruption and stripped of office.

The tapestry shown here was woven in Delft by the talented Flemish craftsman François Spiering (c.1551–1631) to a design by Karel van Mander I (1548–1606). It shows the punishment for excessive pride meted out to Niobe, Queen of Thebes, by Apollo and Diana on behalf of their mother, Latona. Niobe was left to suffer eternally after her husband and children (seen in the forest beyond) were killed.

Knole, Kent · Tapestry depicting Niobe's Pride · *François Spiering · c.1590–c.1610 · Wool and silk, 8 warp threads per cm · 335 x 525cm · Signed on the lower border 'FRANCISCVS SPIRINGIVS FECIT' · NT 130081.3 · ‡ 1966*

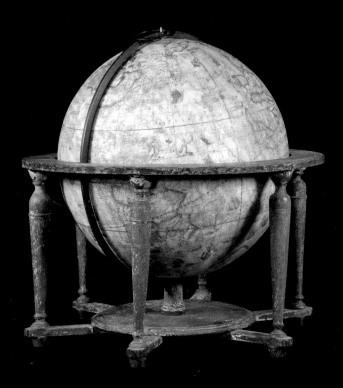

The first English globe

In the 16th century, accurate maps and globes were critical to planning trade, maritime navigation, foreign policy and warfare. Indeed, the quality of the information they supplied could determine success or failure, life or death. It is hard to overestimate the importance of this globe at Petworth, West Sussex, as it is the first English globe and the only surviving example of the first edition. It was created by the mathematician Emery Molyneux (d.1598) with engravings by the Dutch émigré Jodocus Hondius (1563–1612) using what were described as 'the newest, secretest, and latest discoveries'.

Molyneux presented one of these globes to Queen Elizabeth I, and its production celebrated the role of England as a maritime power. Decorated with terrifying sea monsters and an African elephant, it also charts the circumnavigation of the world by Sir Francis Drake (c.1540–96) and a similar attempt by Thomas Cavendish (1560–92), championing the achievements of these famous English explorers. The globe was probably acquired by Henry Percy, 9th Earl of Northumberland (1564–1632), and has been recorded at Petworth since at least 1632.

Petworth, West Sussex · Terrestrial globe · *Emery Molyneux and Jodocus Hondius · 1592 · Paper, plaster, ink, pigment, gesso, sand, beech, oak, brass · 63.5cm diameter x 81.5cm high including stand · Inscribed in cartouches are 'Emerius Mulleneux', 'Iodocus Hondius' and 'Anno Domini 1592' · NT 486024 · ‡ 1956*

The ageless queen

Painted by an English artist when Elizabeth I (1533–1603) was in her sixties, this image reflects the tradition of painting the queen as a timeless beauty. Although her ornate dress looks fantastical, with the underskirt decorated with flowers and land and sea creatures, there is no reason to think it does not record a similar dress owned by the queen. Elizabeth had one of the most extensive and lavish wardrobes of all time, and as late as 1599 she was described as 'most gorgeously apparelled'. The outfit is also covered in hundreds of pearls, a symbol of purity suitable for a virgin queen.

Elizabeth is shown standing full length on a raised platform with her throne to her right. The composition of this portrait may have been adapted from a miniature and was probably commissioned by Elizabeth Talbot, Countess of Shrewsbury (see page 52). It may have been delivered to the countess's home, Hardwick Hall, in 1599, and once installed, it would have provided a visual commentary on Elizabeth Talbot's close relationship with the queen.

Hardwick Hall, Derbyshire · Elizabeth I · *Attributed to Nicholas Hilliard (c.1547–1619)* · *c.1598–9* · *Oil on canvas* · *223.5 x 168.9cm* · *NT 1129128* · *‡ 1958*

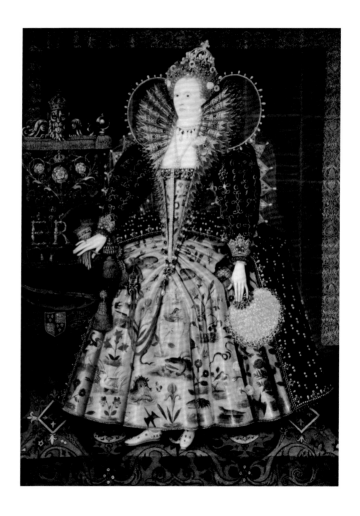

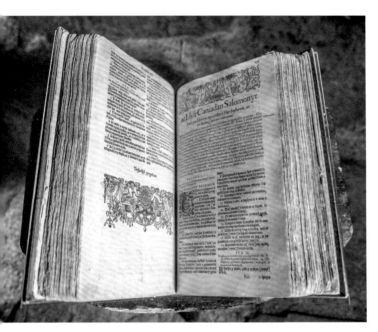

The first Welsh-language Bible

This Welsh translation of the Bible was a change-making book for the Welsh people and for the survival of the Welsh language. Published in 1588, following years of careful translation from the Hebrew and Greek, it was an important legacy of the European Protestant Reformation, bringing the word of God to the people. Although 1,000 Welsh Bibles were published, only about 20 survive, and this copy was held at Tŷ Mawr Wybrnant, the birthplace of its original translator, Bishop William Morgan (c.1545–1604). Welsh language and culture were under threat in Wales following the Acts of Union in 1536 and 1543, so this book – although evangelical in its core purpose – helped to ensure the continued daily use, standardisation and survival of the Welsh language to the present day.

Chirk Castle, Wrexham · Y Beibl Cyssegr-lan, sef yr Hen Destament a'r Newydd · *William Morgan* · *1588* · *Folio volume, letterpress on paper, bound in blind panelled boards* · *29.6 x 20 x 8.8cm* · *NT 3204929* · *Purchased in 2014 from Coleg Harlech with National Trust legacy funds, donations from the Dyffryn, Clwyd and Meirionnydd associations, and local gifts*

In praise of the stag

This exquisite gilded stag cup would have been recognisable as a masterpiece of a goldsmith's work to its original unknown patron or purchaser. It was made by Melchior Baier (d.1634) in Augsburg, the most important centre of fine goldsmith production thanks to its location, trade freedoms and religious tolerance. Baier's studio would probably have worked closely with a sculptor to develop a design for the stag, and the work is so minutely detailed that the animal can be identified as a red deer, an animal hunted only by the nobility. Around its neck the stag wears a pendant hung with a red garnet to further enhance its rarity and beauty. The cup has a removable head and could be used for drinking wine or spirits. However, it is more likely it would have taken pride of place on an elaborate tiered display in a banqueting room, perhaps following a hunting party.

Anglesey Abbey, Cambridgeshire · Cup in the form of a walking stag · *Melchior Baier · c.1600 · Silver gilt embellished with precious stones · 31 x 21.2 x 8.7cm · Maker's and town marks on base · NT 516401*

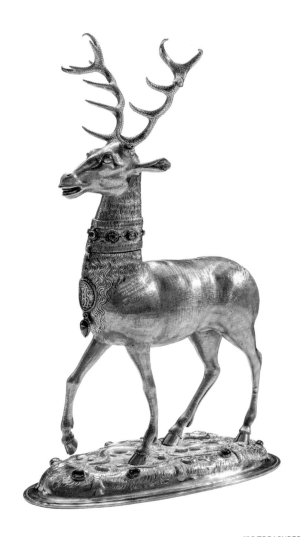

A wonder of Japanese craftsmanship

It is not known how this magnificent Japanese chest came to be displayed at a castle in Wales. It was probably acquired by Sir Thomas Myddelton I (1550–1631) in the late 16th or early 17th century to furnish Chirk Castle near Wrexham. Myddelton, a member of the Elizabethan court and a founder of the East India Company, became Lord Mayor of London in 1613. He made his fortune by investing in the exploits and plundering missions of the Elizabethan seafarers, including Sir Francis Drake (c.1540–96) and Sir Walter Ralegh (1554–1618). It is possible that this chest was a prize from the state-sponsored seizures of Spanish ships around the time of the Armada hostilities in 1588 and the 1590s.

The lacquerware chest is a wonder of artistic ingenuity and was made using techniques that would have been unfamiliar to European craftspeople. Such decorative trunks and boxes – known as Nanban chests – were produced mainly for export to the European market, where they became highly prized. This one is inlaid with mother-of-pearl, sprinkled metal powder and, amazingly, particles of skin from ray fish.

Chirk Castle, Wrexham · Nanban domed lacquerware chest · *c.1600* · *Lacquer (urushi), mother-of-pearl (raden), shagreen (rayskin denticles), gold and silver powder (hiramaki-e), softwood, metal fixings* · *63.5 x 131.5 x 59.2cm* · *NT 1170737* · *‡ 1999*

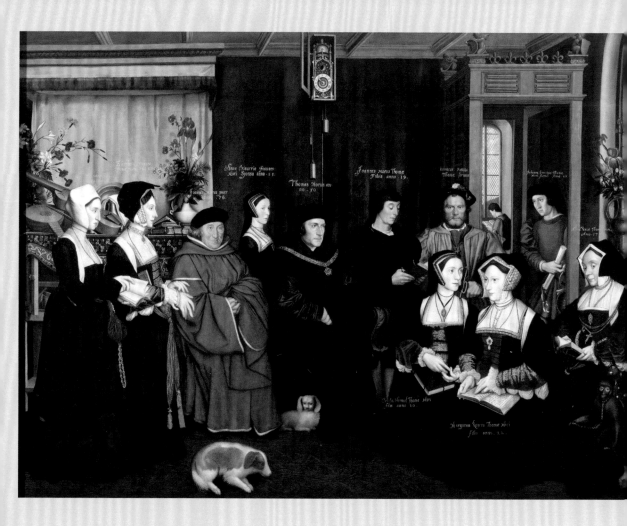

Picturing Tudor family life

This extraordinary group portrait depicts three generations of the family of Sir Thomas More (1478–1535), Lord Chancellor to Henry VIII, who was executed for treason for not supporting the annulment of the king's first marriage. It is a copy or version of a painting from 1527 by Hans Holbein the Younger (1497/8–1543), the most important artist working in England during the 16th century. This copy is traditionally associated with the little-known English artist Rowland Lockey (c.1565–1616) and might have been painted for More's grandson, Thomas, or a member of his daughter Margaret Roper's family, as a way of remembering their history and healing the wounds of More's death and disgrace. A descendant of Margaret married into the Winn family, who lived at Nostell in Yorkshire, and the picture came to the house in 1742 and has remained there ever since. Holbein's original portrait of the family was lost in a fire in 1752, making this copy of even greater importance to the study of his work.

Nostell, West Yorkshire · Sir Thomas More and His Family · *After Hans Holbein the Younger* · *c.1592–c.1620, with a later inscription to Rowland Lockey* · *Oil on canvas* · *249 x 343cm* · *Inscribed lower left: 'Rolandus Lockey/fecit a.d.1592'* · *NT 960059*

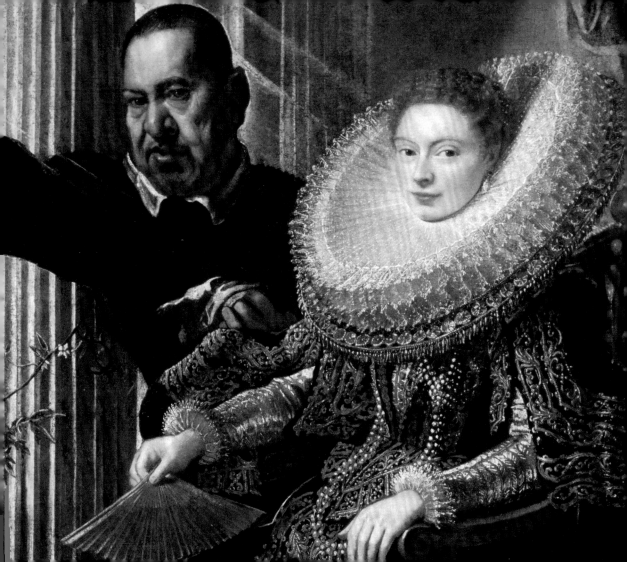

Painting as theatre

Something remarkable happened to the style and sheer ambition of European painting in the early 17th century. The highly influential Baroque artist Sir Peter Paul Rubens (1577–1640) was at the heart of that transformation, and his work was in demand at royal courts and by patrons across Europe. His theatrical style – with dramatic lighting and flamboyantly dressed sitters placed within complex compositions – provided a strong sense of dramatic narrative. The effect was quite unlike painting only a decade previously.

This remarkable portrait is one of his best works and was painted in Genoa, northern Italy, around 1607. It depicts a noblewoman, probably Marchesa Maria Grimaldi (dates unknown), with a gigantic lace collar. Alongside her is an unknown attendant, probably a dwarf, as was reasonably common in noble households. The scene is full of contrasts, energy and movement – such as the small dog jumping up towards the woman and the man pulling back the curtain. The picture was acquired in Italy by William John Bankes (1786–1855) for his house at Kingston Lacy in Dorset.

Kingston Lacy, Dorset · Probably Marchesa Maria Grimaldi and an Attendant · *Sir Peter Paul Rubens* · *c.1607* · *Oil on canvas* · *241.3 x 139.7cm* · *Inscribed bottom left (on dog's collar) 'My AM'* · *NT 1257100*

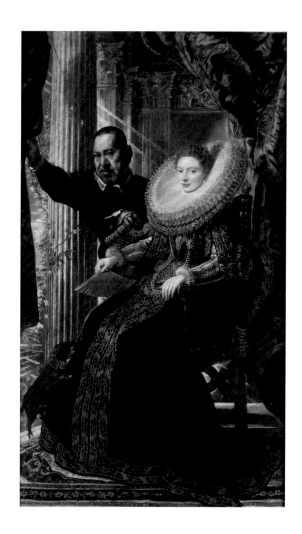

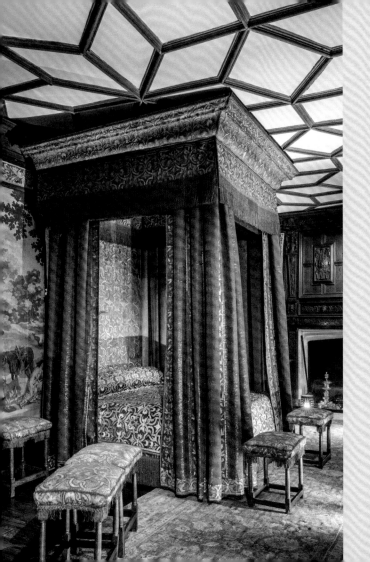

A bed to impress a king

Known as the 'Spangled Bed' due to its sparkling appearance, this spectacular piece of furniture is covered with crimson satin, silver cloth, gold and silver embroidery and tens of thousands of sequins or 'spangles'. It was made in 1621 for Anne Cranfield (d.1669), the wife of a courtier to James I, so that she could receive guests in style in her London house before and after the birth of her son James.

Anne's husband Lionel Cranfield (1575–1645), 1st Earl of Middlesex, served the king as Master of the Great Wardrobe and supplied the court with furnishings and furniture. He appears to have ordered this sequinned four-poster bed as part of a set, with an accompanying cradle, chairs and stools covered in the same crimson and silver fabric. The grand furniture may actually have been designed to impress the king, as James I became godfather to the couple's child. It can be seen today in newly restored splendour at Knole, near Sevenoaks in Kent.

Knole, Kent · The Spangled Bed · *Attributed to Oliver Browne and John Baker, Upholsterers to the Great Wardrobe, and other craftsmen · 1621 · Timber bedframe hung with crimson silk satin, with two designs of paned and strapwork appliqué, decorated with gold and silver embroidery, 'gold twist' and 'spangles' (silver and silver-gilt sequins) · 350 x 242 x 242cm · NT 129462 · ‡ 1966*

A romantic gesture or religious testament?

This dashing and handsome man has chosen to have himself depicted as though consumed by love and passion. He wears classical dress and is shown engulfed in flames, as if to indicate his mental state or fiery ambition. Just above the sitter's head is a Latin motto, *Alget qui non ardet* ('He grows cold who does not burn'), perhaps suggesting that romantic love or religious passion is essential to life. He has been tentatively identified as William Strachey (1572–1621), an acquaintance of the poet and clergyman John Donne (1572–1631) and a member of the Virginia Company, who was shipwrecked on Bermuda in 1609 and returned to tell the tale.

Miniatures were often presented as gifts encased in jewelled lockets and addressed personal and intimate subjects. Isaac Oliver (*c.*1565–1617) was one of the most celebrated miniaturists and had been a pupil of the renowned Nicholas Hilliard (1547–1619). The picture has been displayed in the 'Green Closet' at Ham House in Richmond upon Thames, Surrey, since 1677.

Ham House, Surrey · A Man Consumed by Flames · *Isaac Oliver · c.1610 · Watercolour and body colour with gold on vellum · 5.2 x 4.4cm · NT 1139627*

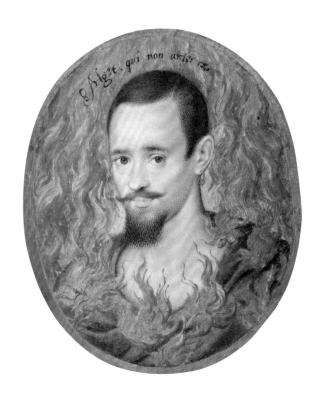

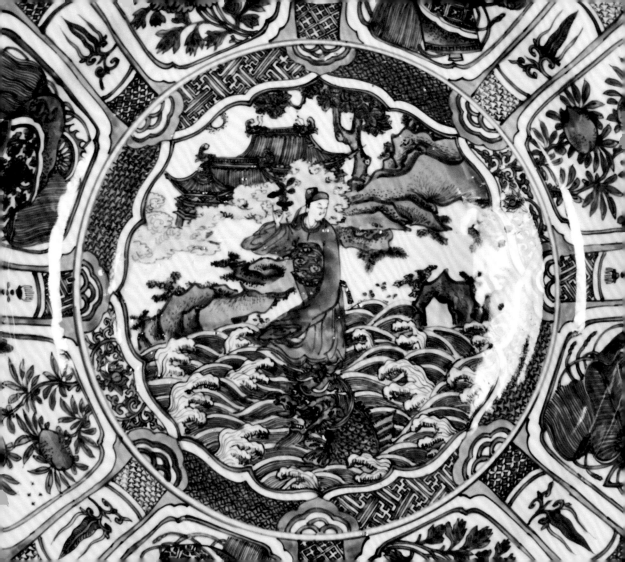

The wonder of Chinese porcelain

When this beautiful blue-and-white dish arrived on European shores as part of a cargo from China, no European could yet match the exceptional craftsmanship evident in its manufacture. The art of making porcelain in its perfectly white hard-paste form was unknown in the West until the early 18th century. Blue-and-white china was first imported to Europe by the Portuguese and Spanish, and then in the 17th and 18th centuries by the Dutch and English. Its unique qualities ensured it found a ready market, and the Western passion for collecting blue-and-white Chinese porcelain lasted for several centuries. The product became known as 'china' because of its origins and came to represent for Europeans a notion of 'exotic' elegance and sophistication.

The type of decorative design on this exquisite large dish is known as *kraak*, perhaps after the type of ships (known as *carraca*) that first traded with Asia. Here it consists of complex religious symbols, including a carp turning into a dragon, a flaming wheel, a fan and a gourd, which would have been largely unfamiliar to Western audiences.

Wallington Hall, Northumberland · Kraak dish · *Unknown workshop and kiln in Jingdezhen, China · c.1610–35 · Blue-and-white porcelain · 50.8cm diameter · NT 581681 · Given with the property by Sir Charles Philips Trevelyan, 3rd Bt, in 1941*

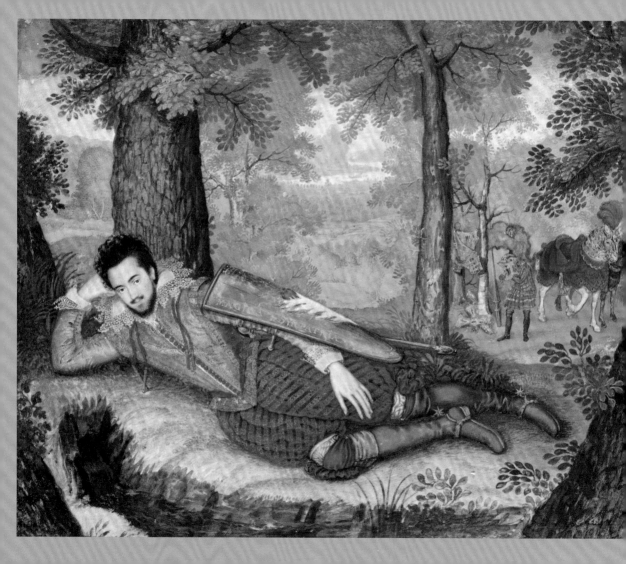

Posing like a poet

Reclining on a grassy bank beside a trickling stream and looking directly at us, this young man knows how to pose like a poet and lover. As if to underline this, his shield sports a heart engulfed in flames. Sir Edward Herbert (1581/2–1648) was a courtier, soldier, diplomat and man of letters. His sumptuous costume of silver and blue matches the livery of his horse in the distance, and this, along with his shield, suggests he is resting after a royal jousting tournament. Such events were entertainments for the monarch and provided an opportunity for an ambitious courtier to demonstrate his skill and bravery.

One of the most charming and beautifully painted portrait miniatures of the Jacobean age, this small picture is by the court artist Isaac Oliver (c.1565–1617), who specialised in such small-scale wonders.

Powis Castle, Powys · Sir Edward Herbert, later 1st Baron Herbert of Cherbury · *Isaac Oliver · c.1613–14 · Watercolour on vellum mounted on panel · 18.1 x 22.9cm · NT 1183954 · Purchased by private treaty with the help of grants from the National Heritage Memorial Fund, the Art Fund, a fund set up by the late Hon. Simon Sainsbury and a bequest from Winifred Hooper, 2016*

An English Persian and his wife in Rome

These fascinating portraits of the Englishman Sir Robert Shirley (1581–1628) and his wife Lady Teresa Sampsonia (c.1589–1668), both dressed in Persian clothes, were painted in Rome in 1622. Robert Shirley was an adventurer, who from 1608 served as ambassador to the Persian shah Abbas the Great (1571–1629) and adopted Persian customs. Teresia Shirley was Circassian (people from the north-east shore of the Black Sea in Russia) and is shown seated demurely against a view of Rome. The painter, Sir Anthony van Dyck (1599–1641), may have been attracted to painting these sitters partly as a result of the stunning visual effect of their lavish clothes.

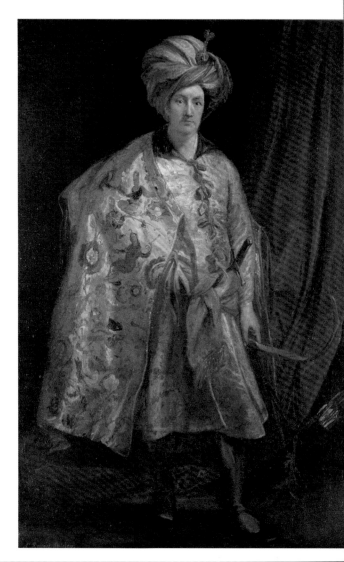

Van Dyck was perhaps the most highly acclaimed and influential artist in the 17th century. He excelled at portraiture and narrative scenes, and the style he created went on to be admired and emulated for centuries. It is not known whether these portraits were a commission from the sitters, or when they came into the collections at Petworth, but they were hanging at the house by 1775 and can still be seen there.

Petworth, West Sussex · Sir Robert Shirley and Lady Teresa Sampsonia · *Sir Anthony van Dyck* · 1622 · *Oil on canvas · Both paintings 214 x 129cm · Sitters' names inscribed lower left and lower right · NT 486169 and NT 486170 · ‡ 1956*

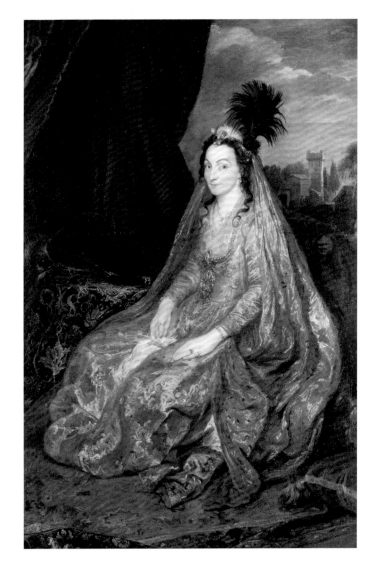

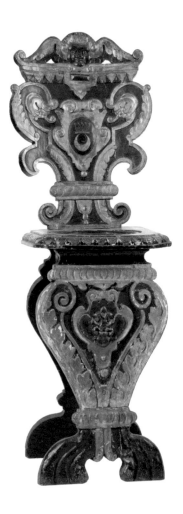

Italian style in England

This stylish chair is part of a set of nine that is likely to have been purchased in 1636 by Algernon Percy, 10th Earl of Northumberland (1602–68) for his house in London. The elaborate and ornamental design (perhaps by Francis Clein, c.1582–1658) was directly influenced by Italian style, and similar chairs – known as *sgabelli* (stools) – were popular in Italy in the late 1500s.

Although it would have been possible to perch on these chairs, perhaps while waiting in a hall, they were chiefly designed to impress and furnish a grand chamber or gallery. These examples were carefully looked after and remained in use at the family's home at Petworth House in West Sussex for several centuries, and were documented as being on display in the Marble Hall in 1750.

Petworth, West Sussex · Chairs or backstools of *sgabello* type · *Probably designed by Francis Clein* · *Unknown maker* · *c.1620–40* · *Elm and oak, painted and partly gilded* · *103 x 33 x 40.5cm* · *NT 485391* · *‡ 1956*

Martyr or overmighty monarch?

This gleaming gilt-bronze bust of King Charles I (1600–49) by the French sculptor Hubert Le Sueur (c.1580–1658) shows him in the mid-1630s in an idealised style and was on view at the Palace of Whitehall in London during his reign. The fashionable style and craftsmanship would have impressed palace visitors, and they would also have noted his helmet topped with a dragon, an allusion to St George, England's patron saint. Charles I was a lavish patron of artists and a lover of his own image. This was one of the many likenesses of himself or his family that he commissioned from some of the most talented and fashionable artists across Europe and that were displayed in his many palaces.

After several years of bloody civil war, the authoritarian and quarrelsome king was deposed and executed in one of the most audacious acts in British history. This bust of the king was sold around 1650, but its value as a work of art was recognised, and it was preserved, possibly by royalist sympathisers, or by those who considered Charles a martyr. By the mid-18th century it was recorded at Stourhead in Wiltshire, where it is still displayed.

Stourhead, Wiltshire · Bust of King Charles I · *Hubert Le Sueur* · *c.1636* · *Gilt cast bronze* · *68 x 62 x 30cm including carved touchstone pedestal* · *NT 731855*

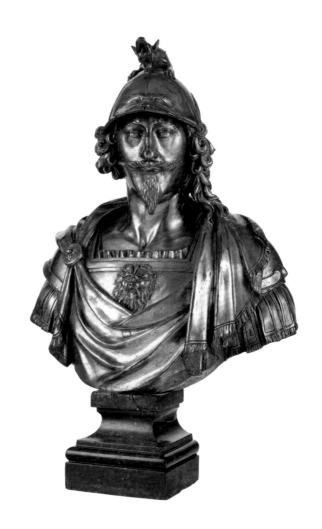

The most famous artist's face

One of the most famous artists of all time, Rembrandt van Rijn (1606–69) repeatedly used his own face to practise and demonstrate his craft. Many of his self-portrait paintings and drawings survive, and this one was painted in 1635, when he had recently moved from Leiden to Amsterdam and begun a successful career. Here we see him dressing up as a wealthy adventurer. He wears a flamboyant plumed hat, a short velvet cloak embroidered with gilt and jewelled adornments, and (bizarrely) a military metal neckband (gorget) from a suit of armour. The lighting is as theatrical as the outfit, and Rembrandt appears to be experimenting with the use of angled light and looming shadows to create a sense of brooding or impending drama.

Although the portrait is signed and dated, its attribution was once considered doubtful. However, it has recently been subjected to cleaning and scientific analysis and has been confirmed as a work by the master's hand.

Buckland Abbey, Devon · Self-portrait, Wearing a Feathered Bonnet · *Rembrandt van Rijn* · *1635* · *Oil on panel* · *91.2 x 71.9cm* · *Inscribed lower right 'Rembrant / f 1635'* · *NT 810136* · *Gifted from the estate of the late Edna, Lady Samuel of Wych Cross, in 2010*

Treasured portrait of a lost prince

This portrait of a six-year-old boy wearing simple hunting clothes shows Prince Baltasar Carlos (1629–46), heir to the throne of Spain. He stands holding his gun with three dogs at his side: the two greyhounds are alert and upright, while the large brown-and-white hound (identified as a partridge dog) snoozes on the ground. This is one of a number of paintings of the prince by Spanish court artist and master of portraiture Diego Velázquez (1599–1660). Here he creates a scene that presents the young Baltasar in the role of a huntsman, in command of the forces of nature. The picture was designed to hang at a royal hunting lodge, where only the nobility was admitted. Tragically, the prince was to die young, at the age of 16, crushing the hopes of his parents, King Philip IV of Spain (1605–65) and Elizabeth of Bourbon (1602–44).

Ickworth, Suffolk · Prince Baltasar Carlos, Aged Six, as a Hunter · *Diego Velázquez* · *1635–6* · *Oil on canvas* · *153.7 x 90.2cm* · *NT 851780* · *‡ 1956*

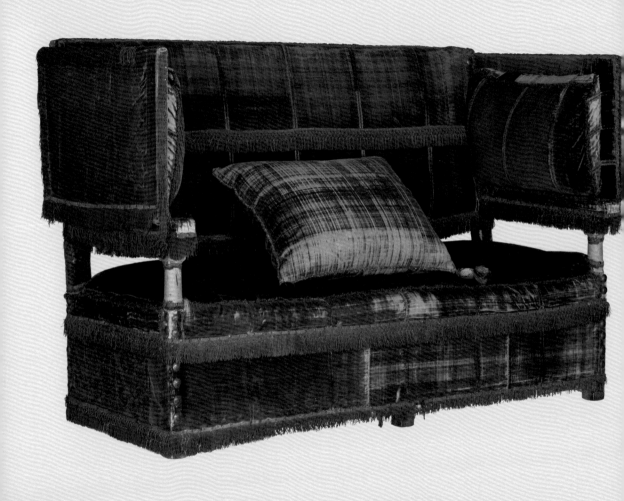

The invention of comfort?

Today a sofa often feels like an essential part of the home, helping us to relax or socialise in comfort. Amazingly, the word (written as 'saffaw') was first used in the 1600s, and the object shown here is one of the earliest surviving examples of an upholstered couch. The design was influenced by furniture from Italy and France, and was originally made for use in Stuart royal palaces. It was covered in crimson velvet and was part of a grand suite of furniture that included two other sofas, six chairs and eight stools. It was probably moved from one of the royal palaces (Hampton Court is stamped under the seat of a comparable chair) to the house of Charles Sackville, 6th Earl of Dorset (1643–1706), at Knole in Kent in the 1690s.

The design later became a classic and was regularly copied and reinterpreted, particularly from the Victorian period onwards.

Knole, Kent · 'The Knole Sofa', a state couch with wings adjusted by iron ratchets · *Unknown London workshops, possibly suppliers to the Great Wardrobe · c.1635–40 · Beech covered with silk velvet and passementerie (braid and fringing) · 104 x 172.5 x 56cm · NT 129442 · ‡ 1966*

The rich Glutton.

Chap. xcvij.

C. 16

19 ¶ There was a certain rich man, which was clothed in purple and fine linen, and fared sumptuously every day.

20 And there was a certain begger named Lazarus, which was laid at his gate full of sores:

21 And desiring to be fed with the crumbs which fell from the rich mans table: moreover the dogs came and licked his sores.

22 And it came to passe that the begger died, and

C vj

Then said he unto the Disciples, * It is impossible but that offences will come, but wo unto him through whom they come.

2 It were better for him that a milstone were hanged about his neck, and be cast into the Sea, then that he should offend one of these little ones.

3 ¶ Take heed to your selves : * If thy brother trespasse against thee, rebuke him, and if he repent, forgive him.

4 And if he trespasse against thee seven times in a day, and seven times in a day turn again to thee,

saying, I repent, thou shalt forgive him.

5 And the Apostles said unto the Lord, Increase our faith.

6 * And the Lord said: If ye had faith as a grain of mustard seed, ye might say unto this Sycamine tree, Be thou plucked up by the root, and be thou planted in the Sea, and it should obey you?

7 But which of you having a servant plowing, or feeding cattell, will say unto him by and by when he

30 Even thus shall it be in the day when the Sonne of man is revealed.

31 In that day he which shall be upon the house top, and his stuffe in the house, let him not come down to take it away, and he that is in the field, let him likewise not return back.

32 * Remember Lots wife.

33 * Whosoever shall seek to save his life, shall lose it, & whosoever shall lose his life, shall preserve it.

34 * I tell you, In that night there shall be two men in one bed, the one shall be taken, the other shall be left.

35 Two women shall be grinding together, the one shall be taken, and the other left.

36 ¶ Two men shall be in the field : the one shall be taken, and the other left.

37 And they answered, and said unto him, Where Lord ? And he said unto them, Wheresoever the bo-dy is, thither will the eagles be gathered together.

A small religious community in 17th-century Cambridgeshire produced some of the most unusual illustrated religious books of the period. Created between 1625 and 1642, these innovative scrapbooks were beautifully constructed from Continental prints and texts from the New Testament focusing on the life of Christ.

The community was founded at the manor of Little Gidding in Huntingdonshire by Nicholas Ferrar (1593–1637) and his mother, Mary (1553/4–1634). The creation of the books was largely the role of the women of the family. The meticulous techniques of cutting and pasting, disguising paper joins by using heavy pressure, created a new type of product and an inventive approach to book composition. This even led some to speculate that they had invented a form of printing. The volume shown here was made by the 12-year-old Virginia Ferrar (1627?–88), with handwritten additions by her father, John (1588?–1657). The community of Little Gidding was the inspiration for a poem of the same name by the poet T.S. Eliot (1888–1965) in 1942.

Ickworth, Suffolk · The Actions, Doctrine and Other Passages Touching Our Lord & Saviour Jesus Christ as They Are Related by the Four Evangelists · *Virginia Ferrar and John Ferrar · 1640 · Paper and vellum*

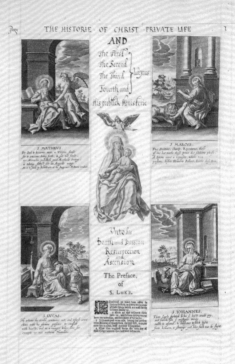

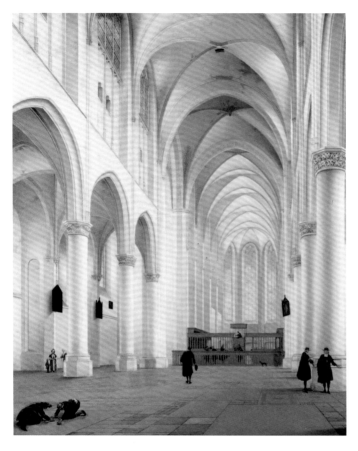

Spiritual space for the word of God

This detailed and skilfully painted picture of an empty church devoid of any adornments was designed to capture and celebrate the simple appearance of 17th-century Dutch Protestant church interiors. It is a study of the empty space as a symbol of Protestant thought, which argued that the written word of God was paramount and that images were false gods. Churches across northern Europe were stripped and remodelled in response to Protestant reformers in the 16th century.

The painting depicts the interior of St Catherine's Church in Utrecht and is by the artist Pieter Janszoon Saenredam (1597–1665), who painted many similar images of identifiable church interiors. The inclusion of people in the scene creates a sense of scale. Two figures in the foreground are kneeling together over a piece of paper, while a couple are seen in conversation, and another man walks into the distance. The visual harmony and purity of this scene, with its whitewashed interiors and figures dressed in black, became a typical theme in Saenredam's work.

Upton House, Warwickshire · The Interior of the Church of St Catherine, Utrecht · *Pieter Janszoon Saenredam* · *c.1660* · *Oil on panel* · *116.8 x 95.9cm* · NT 446733

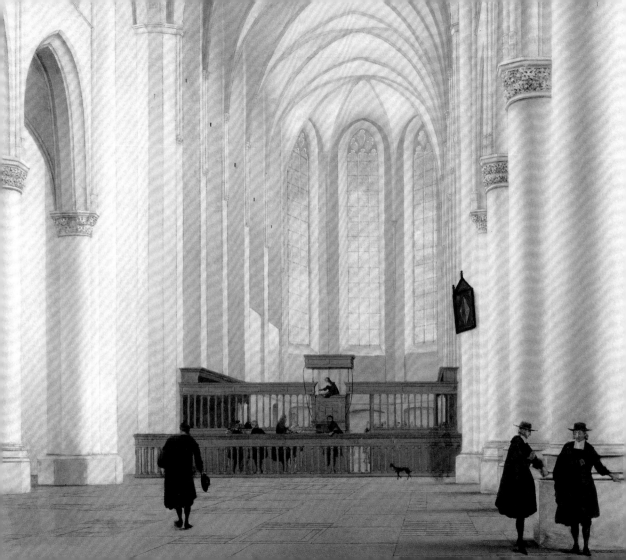

A trick of the eye

As we walk towards this picture, we are intrigued to see an unexpected corridor in front of us. The scene is tantalising, but we can go no further. The corridor is an illusion, a clever trick of perspective, and it soon becomes clear that we are looking at a painted surface. The diarist Samuel Pepys (1633–1703), who saw this picture in January 1663 in the 'low parlour' of the London house belonging to the courtier and collector Thomas Povey (1613/14–c.1705), wrote that 'above all things, I do most admire his piece of perspective especially'.

The painting is full of realistic details, from the inquisitive dog and the alarmed cat to the rooms beyond, where two men and a woman are seated at a table, possibly negotiating a marriage. Painted by the Dutch artist Samuel van Hoogstraten (1627–78), a master of perspective who had been a pupil of Rembrandt, it is considered one of his most accomplished pictures. Its owner Thomas Povey was the uncle of William Blathwayt (?1649–1717), who built Dyrham Park in the 1690s, and the picture was probably on display there shortly after the house was completed.

Dyrham Park, Gloucestershire · A View through a House · *Samuel van Hoogstraten* · 1662 · *Oil on canvas* · *264.2 x 136.5cm · Signed 'S.V. Hoogstrat…/1662' on the letter on the stairs · NT 453733*

How can a Bible help to recover a lost language?

This unusual translation of the Bible provides us with a remarkable window into early North American colonial history. It was written in Wôpanâak, an Algonquian language spoken by some native peoples of the east coast, before European settlers brought about the destruction of existing cultures. This lost language is now being revived with the help of this publication, which effectively provides a key to its reconstruction.

The book was mainly the work of a Puritan missionary named John Eliot (1604–90) and was used to encourage the Native American population to convert to Christianity. Around 1,000 copies were printed, but few survive today, and this copy, from the library at Blickling Hall in Norfolk, includes information about its many early owners. Soon after it was printed, it was sent by John Higginson, a minister of Salem, Massachusetts, to his brother Francis, the rector of Kirkby Stephen in Westmorland (Cumbria), to show the continued spread of Christianity across the world.

Blickling Hall, Norfolk · The Holy Bible translated into the Wôpanâak language · *John Eliot* · *1663* · *Paper, ink, calf binding* · *18.7 x 14.8 x 8.2cm* · *NT 3094668*

NEGONNE OOSUKKUHWHONK *MOSES,*

Ne aſoweetamuk

GENESIS.

CHAP. I.

Eſke kutchiſſik *a* ayum God
Keſuk kah Ohke.

2 Kah Ohke mô matta
kuhkenananunneunkquttinnꝏ
kah monteagunninno, kah
pohkenum woſkeche mꝏ-
nôi, kah Naſhauanit popom-
ſhau woſkeche nippekontu.

3 Onk nꝏwau God *b* wequaiaj, káh mô
wequái.

4 Kah wunnaumun God wequai ne en
wunnegen : Kah wutchadchaûbe-ponumun
God nôeu wequai kah nôeu pohkenum.

5 Kah wutuſſowétamun God wequai Ke-
ſukod, kah pohkenum wutuſſoweetamun
Nukon : kah mô wunnonkꝏꝏk kah mo
mohtompog negonne keſuk.

6 Kah nꝏwau God *c* ſepakehtamꝏudj
nôeu nippekontu, kah chadchapemꝏudj na-
thauweit nippe wutch nippekóntu.

7 Kah ayimup God ſepakehtamóonk, kah

13 Kah mo wunnonkꝏꝏ'k, kah mo moh-
tompog ſhwekeſukod.

14 Kah nꝏwau God, *f* Wequanantéga-
nûohettich ut wuſſepakehtamꝏonganit ke-
ſukquaſh, & pohſhéhettich ut naſhauwe ke-
ſukod, kah ut naſhauwe nukkonut, kah kuk-
kineaſuonganûhhettich , kah uttꝏcheyeû-
hettich, kah keſukodtûꝏwuhhettich, kah
kodtum nꝏꝏwuhhettich.

15 Kah n nag wequanantéganûohettich
ut ſépakehtamꝏwonganit wequaſumóhet-
tich ohke, onk mô n nih.

16 Kah ayum God neeſunaſh miſſiyeuaſh
wequanantéganaſh, wequananteg móhtag na-
nánum ꝏmꝏ keſukod, wequananteg peaſik
nananamꝏmꝏ nukon, kah anogꝏlog.

17 Kah uppónuh God wuſſepakehtamꝏ-
onganit keſukquaſh , woh wequohſumwog
ohke.

18 Onk wohg *g* wunnananumúnneau keſuk-
od kah nákon, kah pohſhémꝏ naſhauen *g* Jer.

Pſal.
3.6.
136.

&c.14.
5.
17.
4.
ebr.
1.3.
2Cor.
6.

Pſal.
36.5.
r.10.
&.

f Deut.
4.19.
Pſal.
á 36.7.

What can art teach us about poverty and dignity?

This scene shows an old woman eating a simple meal of *migas* (a dish made of leftover bread) while being mocked or teased by a laughing boy. It leaves us with questions about the relationship between young and old people and poverty and dignity. The boy looks out to the viewer, gesturing towards the woman, almost as if to ridicule old age itself. The scene is both emotive and uncomfortable. As the viewer, do we look away, side with the young boy, or pity the woman?

The Spanish artist Bartolomé Esteban Murillo (1617–82) was a master of expressive everyday scenes that also captured the pathos of personal hardship. Murillo's work is today often seen as sentimental but was popular across Europe and helped to demonstrate that painting – like poetry and literature – could provoke powerful emotions. The picture was probably purchased in the late 17th century from the Netherlands and brought to Dyrham Park by William Blathwayt (?1649–1717), who commissioned the building of the 17th-century house.

Dyrham Park, Gloucestershire · An Urchin Mocking an Old Woman Eating Migas · *Bartolomé Esteban Murillo* · *c.1665 · Oil on canvas · 147 x 107cm · NT 453754*

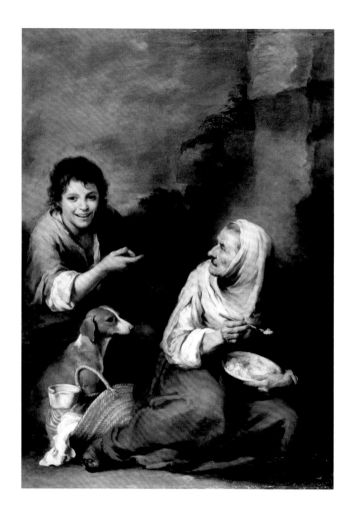

Religious tragedy and passion

Charged with emotion, this picture depicts the martyrdom of St Agatha, a Christian killed in 3rd-century Sicily. Her torture included the removal of her breasts with pincers, and here she is shown holding a blood-stained cloth to her chest while looking towards heaven. The painting appears to record a moment of religious ecstasy and love when St Agatha's wounds were healed as she experienced a vision of St Peter from her cell. It may have been commissioned for display in a private chapel. The Florentine artist Carlo Dolci (1616–87) was known for works that emphasised both the pathos and drama of religious subjects in line with the thinking of the Counter-Reformation movement, which encouraged audiences to connect with the tangible passion and tragedy of biblical narratives.

The picture was probably acquired by the banker Sir Robert Child (1674–1721) for his collection of art displayed at Osterley House in the early 18th century, but it was sold in 1934 and repurchased by the National Trust in 2018.

Osterley House, Middlesex · St Agatha · *Carlo Dolci* · *c.1665–70* · *Oil on canvas* · *88 x 73cm* · *NT 2900293* · *Acquired in 2018 with assistance from a fund set up by the late Hon. Simon Sainsbury, support from the Art Fund, gifts to Osterley Park and a private donation*

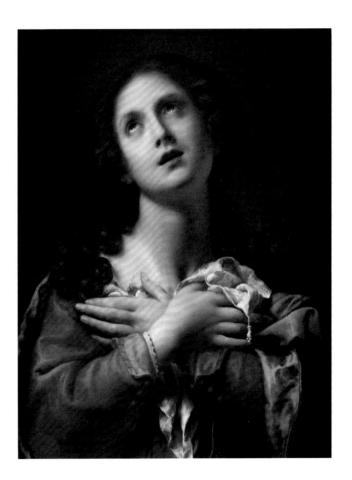

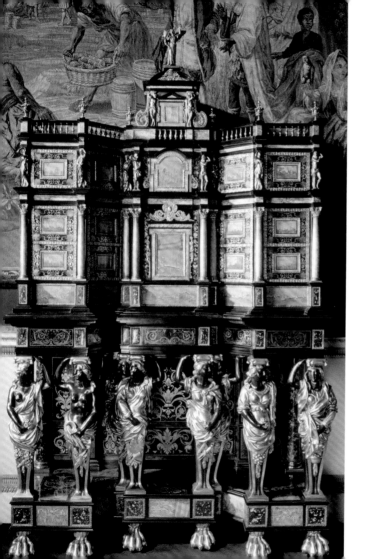

An impressive cabinet for secrets

The National Trust's collections contain some of the most remarkable decorative cabinets in the UK. They were designed as showy, high-status pieces of furniture to grace a room where an elite family's most important guests might be entertained. They also had a practical function, often holding treasured personal items and letters, sometimes in secret drawers.

This cabinet is one of the most impressive and startling. It was made in France in the 1670s by a talented craftsperson, possibly Pierre Gole (c.1620–84), who was associated with the royal factory at Gobelins in Paris. It is designed in the form of an architectural model akin to the façade of a Parisian Jesuit church or its high altar. It probably belonged to Bartholomäus Herwarth or Herwart (1607–76), a German banker living in Paris, who had links to the royal court, and then descended by marriage to the Winn family, who lived at Nostell, Yorkshire.

Nostell, West Yorkshire · Breakfront cabinet on stand in boulle marquetry · *Possibly Pierre Gole (c.1620–84) or an unknown cabinetmaker in his circle · c.1675 · Oak and pine veneered with various woods, including ebony and rosewood, panels of pietre paesine (ruin marble) from the Po valley, painted ivory, richly mounted and inlaid with gilt bronze and pewter · 223 x 140 x 53cm · NT 959731 · ‡ 1986*

A young woman's embroidery project

The pleasure of an intricate craft project is something that many of us still enjoy, even more so when it provides us with beautiful and useful objects to display at home. This late 17th-century box was made by a young woman called Hannah Trapham (her name appears on the lock plate), and she was probably living in or near Canterbury in Kent. Little else is known about her, but she used her impressive needlework skills to decorate this box, which held personal items, such as bottles and, at one time, a mirror. It also had space for a secret drawer.

Typically for this period, the decoration includes animals (such as leopards, squirrels and foxes), flowers and fruit, as well as various biblical scenes, including the story of Jacob's ladder (Genesis 28:10–19). Hannah would almost certainly have copied these designs from European engravings that were in ready supply for such domestic craft projects.

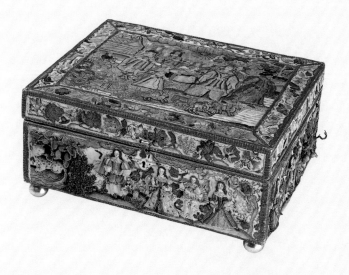

Sudbury Hall, Derbyshire · Box decorated with raised embroidery · *Hannah Trapham* · *1671* · *Wood, silver, silks, chenille, metallic thread, silver-gilt braids, lace, mica and pearls* · *18.5 x 41.5 x 33.5cm* · *Inscribed on lock plate 'Hannah Trapham/1671'* · *NT 653275* · *‡ 1967*

Ordering the abundance of nature

The artist and wood-carver Grinling Gibbons (1648–1721) specialised in an amazing sculptural carving technique that brought together natural forms of fruit, flora, foliage, dead game birds and other animals to create elaborate wall decorations. The effect was to combine the lavish abundance of nature with a symmetrical design, providing an ideal of order as brought about by the human hand. His designs were perfectly suited to a country-house setting, where parties of guests could relax following hunting or other outdoor pursuits.

Gibbons trained in the Netherlands, and his work was particularly fashionable for period interiors in the later 17th century. The use of limewood, a soft and easily worked material with little grain, meant that, following in a tradition established in the Middle Ages, Gibbons could carve deep, elegant forms in a high level of detail. This design was commissioned by George Vernon (1635–1702), the owner of Sudbury Hall in Derbyshire, and can be seen in the house today.

Sudbury Hall, Derbyshire · Carved overmantel · *Grinling Gibbons and workshop · 1678 · Limewood fixed to oak panelling · 345.4 x 182.9cm (whole object) · NT 652745 · ‡ 1984 · The overmantel is pictured here with John Vanderbank the Younger's 1737 portrait of Anne Howard and a page.*

A complement to the wonders of nature

Made to astonish and impress, this delftware vase is one of a pair at Dyrham Park used to display tulips and other flowers. At the time of its manufacture, exotic flowering plants were costly, so each bloom had to be displayed to maximum effect. Flower paintings of this period feature both wild and cultivated flowers such as the violet, poppy, peony, iris, rose, carnation and honeysuckle. With this vase, each spout could display a single stem – as specimens of nature's wonders. The seven tiers each contained water to keep the flowers fresh and beautiful.

The owner of Dyrham Park, William Blathwayt (?1649–1717), worked for the Anglo-Dutch court of King William III (1650–1702) and Queen Mary II (1662–94), and similar vases were known to have been acquired by the queen, who was a passionate collector of delftware. An inventory of the house from 1710 shows that these impressive vases were placed in front of empty fireplaces to create a cheerful focal point to brighten the rooms.

Dyrham Park, Gloucestershire · Flower pyramid ·
De Grieksche A (Greek A) factory, Delft, of Adrianus Kocx ·
c.1690–5 · Tin-glazed earthenware (faience) · 108cm high ·
NT 452205

An adored four-legged friend

This unusual and dramatic portrait of a favourite faithful dog named Pugg or Old Vertue was painted by the Dutch artist Jan Wyck (c.1645–1700) and commissioned by a member of the Booth family at Dunham Massey, Cheshire, around 1700. The dog was a type of bulldog or Dutch mastiff, a breed that was cultivated on the estate for several decades. Previous family owners of Dutch mastiffs had described them as 'Dum, sensible and sincere creatures', and they were employed as lapdogs and probably also to control vermin and sheep.

In this portrait, Pugg's brindle coat is well lit, and he stands theatrically positioned against the skyline with the house in the distance, looking alertly to the left. He can also be seen in the background, busily chasing sheep in an open landscape. The Booth family clearly cherished their pet dogs, as several other portraits (such as Turpin, a speckled Great Dane) still survive at Dunham Massey. Pugg died in 1702 and has a tombstone in the grounds of the house, beginning a tradition of pet burials that continued into the 19th century.

Dunham Massey, Cheshire · Dutch Mastiff (Called Old Vertue) with Dunham Massey in the Background · *Jan Wyck* · *c.1700* · *Oil on canvas* · *61 x 75cm* · *NT 932341*

A sun-god statue for the French royal gardens

The gardens of the chateau of Versailles near Paris, commissioned in the late 17th century by Louis XIV (1638–1715), were among the most carefully designed, spectacular and influential of any period in garden design. This statue of Apollo was probably made for display in the gardens, partly to demonstrate the king's wish to associate himself with the sun god Apollo. Its French sculptor, Jean Raon (1630–1707), spent much of his career making sculpture for the king's palaces.

Here Apollo is shown standing in triumph over the monstrous mythological creature Python at his feet, and it is possible that this may have been read as a reference to the king's victory over French Protestants and foreign enemies. The towering, elongated figure, naked to the waist, is simultaneously powerful and feminised, in common with the flamboyant late baroque style of the French court. The sculpture was acquired by Baron Ferdinand de Rothschild (1839–98) for the gardens of his home at Waddesdon Manor, Buckinghamshire.

Waddesdon Manor, Buckinghamshire · Apollo Triumphant over Python · *Jean Raon · 1699 · Marble · 205.9 x 73.6 x 53.3cm · Waddesdon 6150.1 · Bequest of James de Rothschild, 1957*

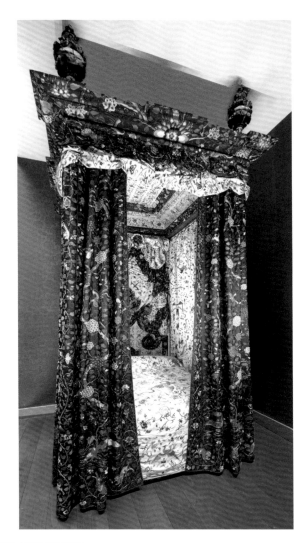

An unused gift

A rare and remarkable survival, this extravagant state bed, with its embroidered Chinese silk hangings, is in near-perfect condition and may never have been used. The striking blue outer curtains, embroidered with birds, dragons, butterflies and trees of silk, gold thread and peacock feathers, contrast with the interior of pale-ivory silk, adorned with a dream-inducing design of human figures, flowering foliage, animals and birds. The desire for high-quality Chinese silk increased during the late 17th century, with workshops manufacturing specifically for the European luxury market.

The bed is thought to have been given as a wedding gift to Lady Caroline Manners (d.1769), on her marriage to Sir Henry Harpur (1708–48) in 1734. Lady Caroline had served as a maid of honour to Princess Anne, daughter of George II and Queen Caroline, and the bed may have been made for George I around 1715. It was possibly out of fashion by the time it was gifted to the family at Calke Abbey, and at the time the house and its contents were gifted to the National Trust in 1985, it had never been installed.

Calke Abbey, Derbyshire · State bed probably made for George I · *Unknown makers* · *c.1715* · *Wood, wool, linen, silk and feather* · *411.5 x 213.5 x 244cm* · *NT 291768* · *‡ 1985*

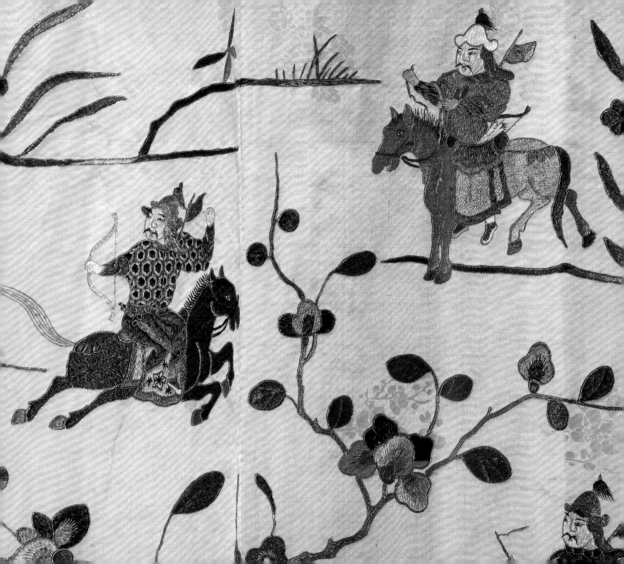

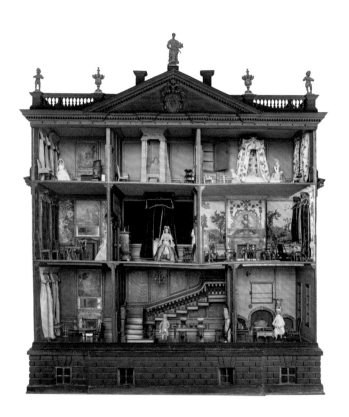

Visitors or voyeurs?
The miniature world of a house

Inside this richly decorated townhouse lies a world of imagination and enchanted play. Looking in from the front, we can see all the rooms at once, having a god-like view of the imagined goings-on of the doll inhabitants. Are we visitors or nosy intruders? Adults have always been as fascinated with dolls' houses as children. In fact, dolls' houses of this quality from the 17th and 18th centuries were not so much children's toys as works of art in their own right.

Each room of this house is beautifully furnished, like a well-decorated house of the early to mid-1700s. Silverware is displayed on the table, the beds are hung with velvet, silk and chintz, and fashionable porcelain is found in several rooms. The house was commissioned by or for Sir Rowland Winn, 4th Baronet (1706–65), and his wife Susanna Henshaw (d.1742), who were married in 1729. They lived at Nostell in Yorkshire and had seven children.

Nostell, West Yorkshire · Dolls' house · *Unknown designer and maker · c.1729–42 · Oak, mahogany, walnut, marble, ivory, carved and painted/ebonised wood, glass, brass, gilt bronze, steel, pewter, silk, chintz and other textiles, paper, porcelain, wax candles, wax and composition dolls · 212 x 191.7 x 76.2cm · NT 959710 · ‡ 1986*

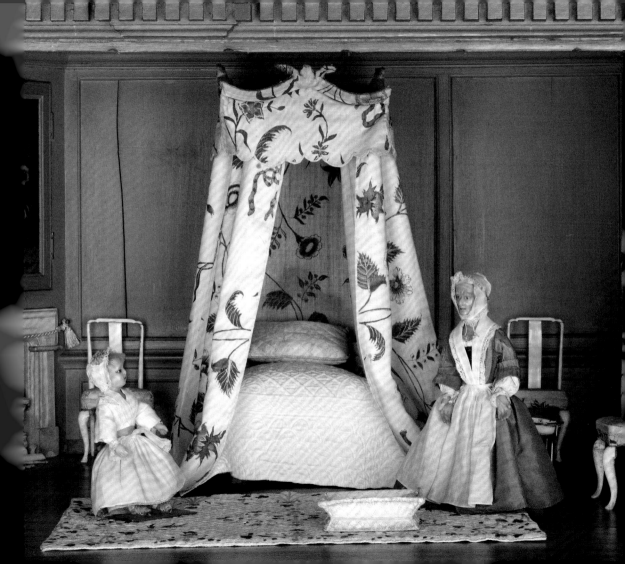

What happened to an 18th-century fashionista's dress?

The brilliantly preserved silk of this court dress, shimmering with gilt thread in a design of red poppies and golden wheatsheaves, would have been the peak of fashion in the 1740s. The dress was made for Lady Ann Bligh (d.1789) shortly after her marriage to Bernard Ward, 1st Viscount Bangor (1719–81), of Castle Ward in Northern Ireland.

The fabric, hand-woven in Spitalfields, London, has a botanical design incorporating white and gold, a feature of formal fashion at this date. Although worn very rarely, the enormous cost of this exquisite dress ensured its survival. The dress was altered in the 19th century and was worn in 1845 to attend a historical ball at Buckingham Palace. However, when worn by Ann Bligh in the 1740s, the skirt would have been stretched out over a wide hoop of 150–180cm. To move gracefully in this type of dress would have required considerable practice and agility. For the Victorian ball, the voluminous skirt was dramatically altered to a more fashionable shape.

Springhill, County Londonderry · Court mantua dress · *Unknown maker · Late 1740s · Ivory silk brocade with silver-gilt metal thread and gold braid · NT 603183 · Gifted by the 6th Earl of Clanwilliam, December 1979*

Bespoke holiday souvenirs from Venice

Unlike many modern holiday souvenirs, this milky white glass plate (one of 16) would have deeply impressed British admirers in the mid-to-late 1700s. The plates were commissioned from a glasshouse on the island of Murano near Venice in June 1741 by John Chute (1701–76), the owner of The Vyne in Hampshire. The prestige of these high-end souvenirs, ordered while on a grand tour, lay in both the material and the designs. The white glass was probably intended to imitate porcelain imported from China during this period. The painted red-enamel scenes, which include views of the Grand Canal and St Mark's Square, come from designs by Antonio Visentini (1688–1782) and Luca Carlevaris (1663–1730), evidently influenced by the style of Antonio Canaletto (1697–1768). Such scenes helped to popularise the status of Venice as an iconic travel destination at this period.

The Vyne, Hampshire · One of 16 Lattimo glass plates decorated with views of Venice · *Miotti Glasshouse, Murano · 1741 · Lattimo (opaque white glass) copied from engravings by Antonio Visentini and Luca Carlevaris, painted in red enamel · 22.5cm diameter · NT 718641–718656 · ‡ 1956*

Dining in style

In wealthy households in the 1700s, beautifully designed silver tureens steaming with soup were placed at the head of the table for all the assembled diners to see. In Georgian society, the ostentatious display of silver, far from being considered undignified, was an indicator of wealth, taste and judgement. The contents were usually served by the host and hostess, and the tureens themselves became elaborate status objects that took a starring role in the ritual performance of dining.

This one is among the most important pieces of silver in the National Trust's collections. It was commissioned for Ickworth in Suffolk by George William Hervey, 2nd Earl of Bristol (1721–75), who was a great patron to the most talented silversmiths. It is part of one of the most intact dinner services of this period, and its maker was a German émigré, Frederick Kandler (d.1778), who was adept at interpreting Continental fashions for an English market. Hervey's coat of arms and the family crest of a chained snow leopard appear prominently on the tureen.

Ickworth, Suffolk · Pair of tureens (one pictured) · *Frederick Kandler* · *1752–3* · *Sterling silver* · *35.6 x 44.5 x 27cm (No. 1), 36.2 x 44.5 x 27.9cm (No. 2)* · *NT 852127* · *‡ 1956*

Sculpted from life and art

For his sculpture of the mythical hero Hercules, John Michael Rysbrack (1694–1770) was inspired by classical sources. He was particularly influenced by images and copies of the Farnese Hercules (now in the Museo Archeologico Nazionale, Naples), but he also relied on many different live models to help him accurately render the human anatomy. A contemporary commentator records that Rysbrack modelled the arms on those of a local bare-knuckle boxer known as Jack Broughton, the torso on a coachman and the legs on a well-built painter. The statue, signed and dated, took ten years to complete and was the artist's most impressive and celebrated work. It was commissioned by Henry Hoare II (1705–85) for his purpose-built Temple of Hercules within a designed parkland at Stourhead in Wiltshire. It cost the very considerable sum of £350, the equivalent of more than £40,000 today. The temple has since been renamed the Pantheon, and the statue is set in a niche alongside a pendent sculpture of the Roman goddess Flora, also by Rysbrack.

Stourhead, Wiltshire · Statue of Hercules · *John Michael Rysbrack* · *1756* · *Marble mounted on grey marble pedestal* · *approx. 195 x 130 x 70cm* · *NT 562911*

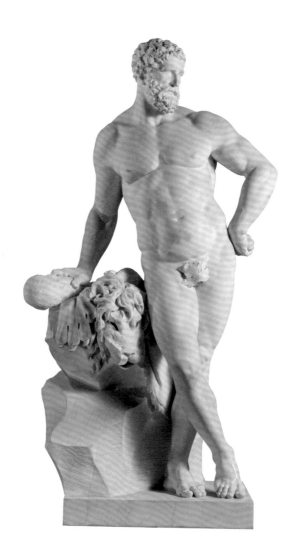

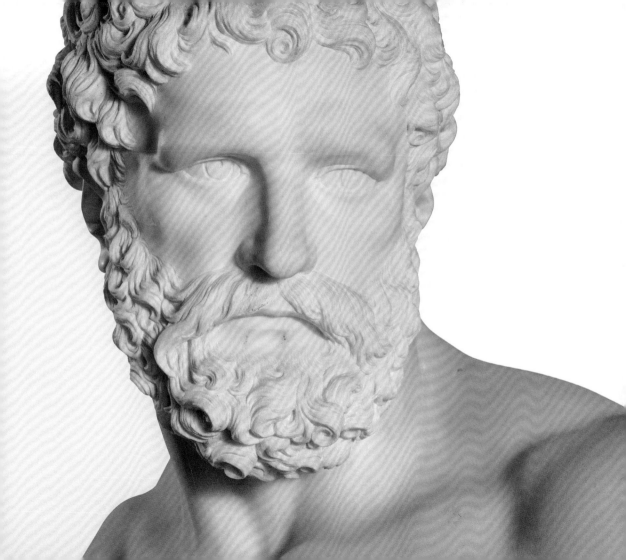

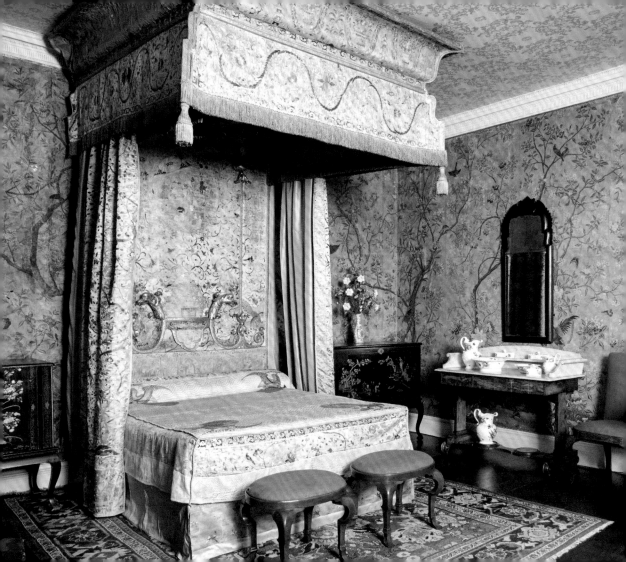

Bringing the outdoors inside

Sometime during the 1770s a couple in North Wales decided to redecorate their house. They had the advantage of being able to afford some of the best craftspeople and to purchase some of the most fashionable products on the global market. The couple were Philip Yorke (1743–1804) and his wife Elizabeth (1749–79), who lived at Erddig, near Wrexham. The decoration they chose for their principal bedroom was hand-painted Chinese wallpaper, lavishly decorated with exquisite birds and flowers. The painting was delicate and keenly observed, and the detail (right) shows chickens amid picturesque flowering shrubs and trees against a pale green background. Other sections of the design include egrets, ducks, pheasants and even mythical phoenixes.

Towards the end of the 1700s the fashion for Chinese products with naturalistic designs was at its height, and many were made especially for a Western market. Wealthy buyers could purchase porcelain, fabrics and lacquer furniture with a busy array of bird, flower and landscape designs, thus bringing the outdoors into the home.

Erddig, Wrexham · Bird and flower wallpaper · *Unknown painting workshop, probably in Guangzhou, China* · *c.1770* · *Ink and pigments on paper* · NT 1153114

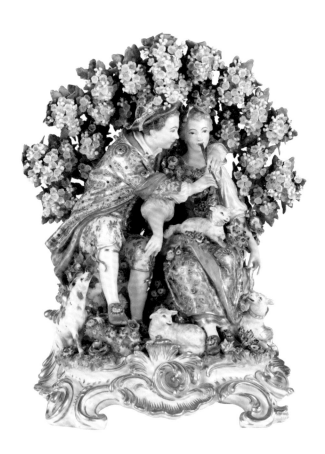

Objects of desire for a luxury market

The Chelsea porcelain factory, established around 1743–5, produced some of the most desirable ceramic figures of any period. The secret of its success was in the quality of the manufacture and the choice of subjects, which often featured delightful pastoral scenes, with romantic or sexual overtones, and idealised animal figures. At this period, the material was a soft-paste porcelain because European makers had not yet mastered the East Asian art of producing hard white porcelain.

The sculpture group shown here is known as *The Agreeable Lesson* and is one of the largest and most appealing produced by the Chelsea factory. It features a shepherd teaching a shepherdess to play the pipes, a composition inspired by a print after a painting by the French artist François Boucher (1703–70). The profusion of small flowers in the arbour and the shepherdess's hand on the shepherd's knee creates a heady sense of romance and sexual tension.

Upton House, Warwickshire · Figure group *L'Agréable Leçon (The Agreeable Lesson)* · *Modelled by Joseph Willems (1716–66)* · *Chelsea Porcelain Factory, London* · *c.1765* · *Soft-paste porcelain, painted and gilded* · *38.1cm high* · *Gold-painted anchor and incised 'R.' marks* · *NT 446192*

Restyling the star of Georgian comedy

The actress Mrs Frances Abington (*c*.1737–1815) was one of the most popular performers on the Georgian stage. She starred in Shakespeare's comedies and tragedies, and in contemporary plays, performing at Drury Lane and Covent Garden in London. She employed Sir Joshua Reynolds (1723–92), one of the most well-respected and important portraitists of the age, to paint her likeness. Ambitious, witty and beautiful, her fame and reputation were heightened by the production of printed images showing her in different theatrical roles.

This portrait shows her in the role of Thalia, the ancient Greek goddess of comedy, and was first painted in 1764–8. However, in 1772–3 she decided to get the portrait updated to reflect the latest fashions, so Reynolds restyled her hair and altered her dress. Despite her humble origins as a soldier's daughter, her wit, reputation and elegance would have set her image apart and she created a successful role for herself as a fashion icon.

Waddesdon Manor, Buckinghamshire · Mrs Abington as the Comic Muse · *Sir Joshua Reynolds, PRA · 1764–8; updated 1772–3 · Oil on canvas · 238.1 x 149.2cm · Waddesdon 2304 · Bequest of James de Rothschild, 1957*

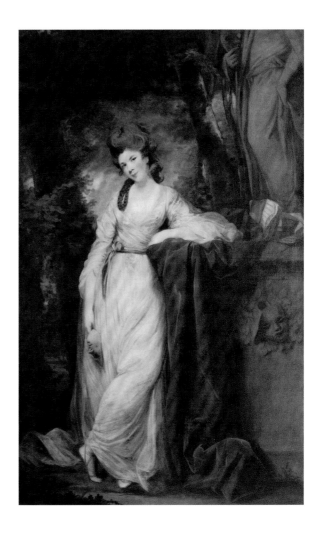

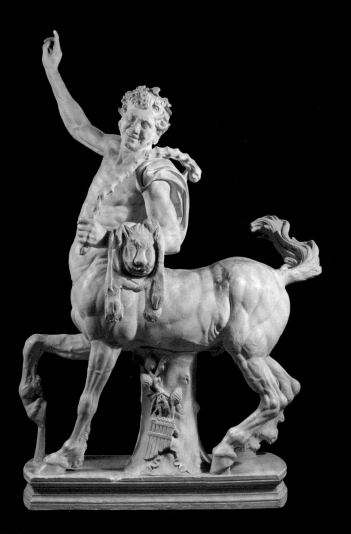

In admiration of ancient art

Following the discovery and excavation of ancient Roman statues in Italy in the 1700s, collectors across Europe became increasingly keen to acquire copies. Artists developed casting techniques in plaster that allowed classical marble sculptures to be copied at scale. These plasters gained popularity as art objects in their own right, and were displayed in galleries and country houses as a way to reference the remarkable skill in design and proportion of classical art.

A pair of marbles known as the 'Furietti Centaurs' (AD117–138) were discovered at Hadrian's Villa outside Rome in the 1730s and displayed for the first time at the Capitoline Museum in that city in June 1765. These two plaster copies by Bartolomeo Cavaceppi (1716–99) are among the earliest known casts of those classical sculptures and were acquired by Thomas Anson (1695–1773) for his house at Shugborough, Staffordshire. The mythical creatures known as centaurs were half-human, half-horse, and these sculptures represent the young centaur Nessus (left) holding a club and lionskin, and the old centaur Marsyas (right) with his hands bound behind his back.

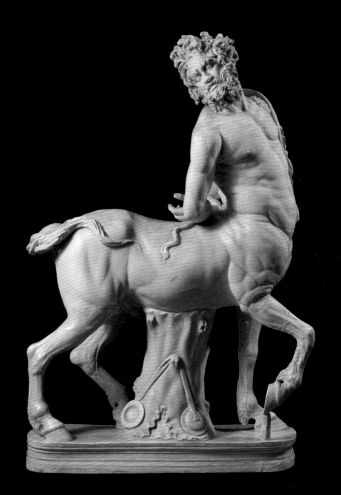

Shugborough Hall, Staffordshire · Casts of the
Furietti Centaurs · *Bartolomeo Cavaceppi* · *1765* ·
Plaster mounted on painted wooden pedestal ·
158 x 113 x 63cm (left); 145 x 100.5 x 49.5cm (right) ·
NT 1271313 (left) and NT 1271312 (right) · ‡ *1966*

A design classic

The 18th-century country-house library was a place to read, correspond and study, but it could also make a statement about the owner's learning and status. When the furniture-maker Thomas Chippendale (1718–79) supplied a 'large mahogany library table' to Sir Rowland Winn (1739–85), 5th Baronet, the owner of Nostell in Yorkshire, he stated proudly on the invoice that it was 'finish'd in the most elegant taste'. The design – a classic and much copied – was the most expensive piece of furniture Chippendale supplied for Nostell. Winn was greatly influenced by his architect Robert Adam (1728–92), whose ordered and elegant designs set the fashion for this period. Winn must have been particularly pleased with this desk, as it features in a double portrait of him and his wife Sabine (1734–98).

The desk was made of mahogany, then in high demand for all types of furniture because of its rich colour and ease of handling. However, its popularity led to a system of production that has a darker history, as it was harvested in the Caribbean by enslaved people.

Nostell, West Yorkshire · Library table · *Workshop of Thomas Chippendale · 1766 · Mahogany, oak, deal, brass, gilt brass, castors of iron and timber (possibly beech), leather · 78 x 204 x 128cm · NT 959723 · ‡ 1986*

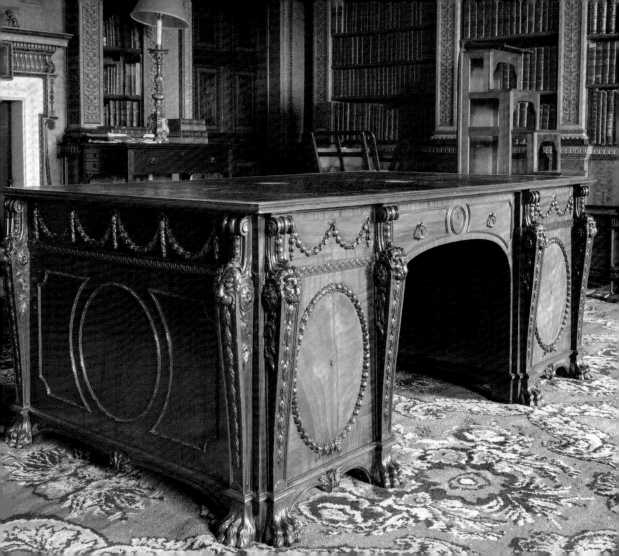

Reflections of guests in a gilded mirror

For more than 250 years this impressive giltwood mirror has captured the reflections of the faces of guests at Kedleston Hall in Derbyshire. Made for Nathaniel Curzon, 1st Baron Scarsdale (1726–1804), it hangs within the dressing room of the State Apartments used by his most prestigious guests and must have witnessed very important and glamorous society figures preparing themselves for receptions and dinners. It was made by a cabinetmaker from Derby and probably designed in collaboration with the architect and designer Robert Adam (1728–92). The tropical palm-tree design was also used on a set of matching candle stands and a state bed, creating one of the most impressive and elaborate 'spare rooms' in history.

Kedleston Hall, Derbyshire · Carved and gilded mirror in the form of palm trees and fronds · *Perhaps designed by Robert Adam and executed by James Gravenor and John Hall* · *After 1768 · Giltwood and glass · 458 x 244cm · Inscribed beneath the arms, supporters and coronet of Lord Scarsdale with the family motto 'Recte et suaviter' [Justly and mildly]* · *NT 108624 · Acquired in 1988 with support from the National Heritage Memorial Fund*

Illumination for the dancing crowds

The Assembly Rooms in Bath were a popular destination for fashionable and polite society in the late 18th and early 19th century, hosting glamorous balls, concerts and teas. The novelist Jane Austen (1775–1817) visited on several occasions and set scenes from her novels *Northanger Abbey* (1817) and *Persuasion* (1818) at Assembly Room balls. The rooms, first opened in 1771, received visitors throughout the autumn, winter and spring, and balls began in the early evening, continuing until midnight. Unsurprisingly, the lighting in the ballroom was important to heighten the drama of social occasions, bringing a sense of opulence and glittering magnificence.

Five spectacular glass chandeliers illuminate the ballroom, each with 40 double-curved lead-crystal arms for wax candles. They were made by William Parker (active *c*.1756–1800), who had a workshop in Fleet Street, London, and they still hang in the Assembly Rooms today.

Bath Assembly Rooms, Somerset · Set of five chandeliers · *William Parker* · 1771 · *Lead crystal and silvered brass* · approx. 244cm high · NT 67104–8

Waddesdon Manor, Buckinghamshire · Musical
automaton in the form of an elephant · *Hubert Martinet* ·
1768?–72 · Bronze, chased and gilt, mother-of-pearl,
glass, pastes, oil paint and wood · 137.1 x 85.1 x 63.8cm ·
Waddesdon 2202

A mechanical wonder

When it was first completed and unveiled,
gasps of wonder and amazement would have
met this mechanical elephant sumptuously
decorated with gilt-bronze and imitation jewels.
This spectacular object can be wound up like
a clock, and a musical box in the base plays
four unidentified tunes as the creature begins
to move its trunk, roll its eyes, flap its ears and
swish its tail. Sometimes known as 'sing-songs',
elaborate musical automata in the form of exotic
creatures were objects of great curiosity and
wonder for audiences in the late 1700s. This one
was made by Hubert Martinet (active 1770–90),
a talented French clockmaker based in London.
It was put on show in Paris shortly after it was
made, and by 1853 it appeared in a mechanical
museum in Rheims, France, and it was thereafter
displayed in several other European cities.

The elephant was acquired by Baron Ferdinand
de Rothschild (1839–98) and was on display at
Waddesdon Manor, Buckinghamshire, by 1889,
when it delighted the Shah of Persia, Nasir al-
Din Shah (1831–96), during his official visit.
It still amazes visitors to Waddesdon.

A great carpet for a Great Room

Carpets appear to be a particularly British obsession. Many small-scale, high-quality carpets were imported for use on tables in the 16th and 17th centuries, while rush matting was used on floors. Woven wool started to appear on the floors of wealthy homes in the early 1700s, providing greatly improved comfort, warmth, colour and a sense of luxury. By the 1750s, carpet factories were set up by weavers around London and in Axminster, Devon.

One of the most significant and important carpets owned by the National Trust is this fine Axminster, which was commissioned for the Great Room (now known as the Saloon) at Saltram in Devon by John Parker (1734–88) and his wife Theresa (1745–75), and installed in 1770. It was designed by the celebrated architect Robert Adam (1728–92) to reflect the plasterwork ceiling, creating an elegant and harmonious effect. The carpet remains in place, and the room is one of the finest and most complete Robert Adam interiors.

Saltram House, Devon · Carpet · *Thomas Whitty* · *1770* · *Wool* · *512 x 782cm* · *NT 872449* · *‡ 1957*

East Indian furniture for European merchants

Patterns of flowers and trees from Indian textiles have been combined with designs from 18th-century Anglo-Dutch furniture to create this striking cabinet. Probably made for Western merchants or officials working in India, it is made from rosewood or padouk and is inlaid with engraved ivory decoration. In the late 1700s the Indian port of Vizagapatam (today called Visakhapatnam, the largest city in the district of Andhra Pradesh) became a well-known centre for the production of Anglo-Indian furniture and textiles for a Western market.

In this example the very high quality of the craftsmanship is evident in the interior, which is designed to impress as the doors are opened. The interior is laid out as galleried rooms with ivory columns and balustrades, and the 'walls' are fitted with drawers. It is possible that the cabinet came to Kingston Lacy in Dorset as a gift for a former owner, George Bankes (1787–1856), who had been Commissioner of the India Board and also sat on the board of the East India Company. Such examples of inventive cross-cultural design and manufacture were celebrated and promoted at the 1851 Great Exhibition in Hyde Park, London.

Kingston Lacy, Dorset · Cabinet on stand · *c.1760–70* · *Rosewood or padouk and ivory · 163 x 110 x 77cm* · *NT 1254548*

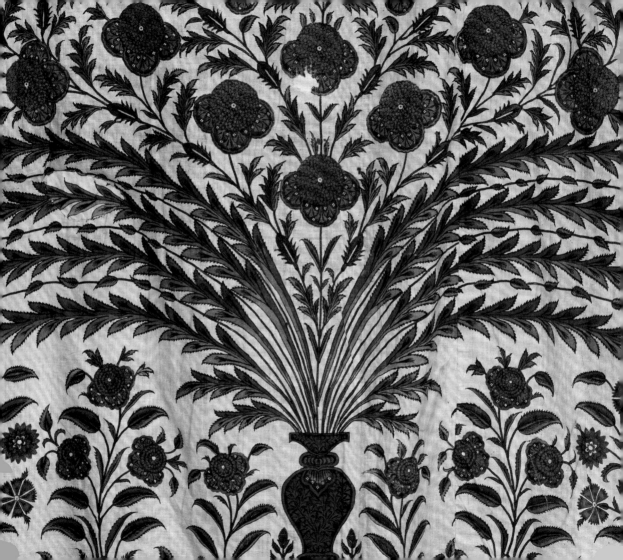

A tent fit for a sultān

This magnificent campaign tent for Tīpū Sultān (1750–99), the ruler of Mysore in southern India, reused earlier tents from the late Mughal period, c.1725–50. The interior is lavishly decorated like a palace, using red, white, green and blue chintz-cotton fabric, which creates an illusion of panelled niches, each with a vase displaying red floral blooms. The design also includes a tiger motif, Tīpū Sultān's personal emblem. Although the tent still creates an enchanting space, some of the fabric dyes have faded, and the yellow decoration is no longer evident. Externally, the tent was plain white cotton with a red-and-white striped roof.

The British regarded Tīpū as the last major impediment to taking control of India. His death during the siege of Seringapatam of 1799 was followed by the seizure of the spoils of war, particularly those associated with Tīpū. This tent and many other objects, including Tīpū's travelling bed and parts of his throne, were obtained by Edward Clive, first earl of Powis (1754–1839), while he was governor of Madras (1798–1803) and subsequently became known as The Clive Collection.

Powis Castle, Powys (The Clive Collection) · Tīpū Sultān's Tent · *late 18th century · Unknown maker · Cotton chintz, natural cotton calico, some internal bamboo poles and iron shoes · 240cm high at apex; 803cm diameter across roof; 58.5sq m in total · NT 1180731 · Purchased from the Earl of Powis and the Powis estate trustees, with support from the National Heritage Memorial Fund and the Art Fund, 1999*

Memorial portrait of an unknown young coachman

When this portrait of a young coachman was painted, slavery was still legal in British territories overseas but, technically, illegal in Britain. The use of black servants in European households was common in the 17th and 18th centuries, and black children and young adults were portrayed as attendants in portraiture. This portrait is unusual in that it depicts a black servant in liveried costume as a subject in his own right. However, the young man's name is not certain, and he is known simply by his employer's name and his role in the household: 'John Meller's coachboy'. Although evidence is limited, John Meller (1665–1733) appears to have employed two black servants at his house at Erddig in North Wales.

This portrait was apparently not commissioned, nor was it painted directly from life. It originally represented another sitter named John Hanby, aged 25, and was repainted some 70 years later to tell the story of the black coachman. It was added to the collection of Meller's great nephew Philip Yorke (1743–1804) as part of an established group of servant portraits at Erddig in the late 18th century. The long text at the top right details the hardships of the coachman 70 years earlier and the positive influence of William Wilberforce (1759–1833) in challenging the transatlantic slave trade, which was not abolished in the British colonies until 1833.

Erddig, Wrexham · A young coachman · *Unknown artist* · *Late 18th century* · *Oil on canvas* · *114.3 x 91.4cm* · *NT 1151289*

A thirst for Chinese trade

The decoration on this unusual punchbowl reveals that it was made at a very specific time and place as a souvenir for Western merchants working in China. Dating from around 1786–8, the painted scene on the bowl depicts a 'hong' – a stretch of dwellings, offices and warehouses along the river outside Guangzhou (Canton), which was designed as one of several trading posts for Westerners. At this period, Chinese rulers wanted to control Western influence, so they ensured that only licensed foreign merchants worked in secure trading compounds. Flying above the buildings are the national flags of Denmark, Spain, France, Britain, Sweden, the Netherlands and the USA, thus revealing the various countries that competed to export Chinese tea, silk and fine porcelain back to the West.

 The bowl, which is made of porcelain, was probably purchased in China and brought to England by a returning merchant. However, it is not known why it came to Nostell, and it may have been an unusual second-hand gift.

Nostell, West Yorkshire · 'Hong' punchbowl · *Chinese School · c.1786–8 · Hard-paste porcelain with enamel · 15cm high x 37cm diameter · NT 959642*

Spoils of the Napoleonic Wars

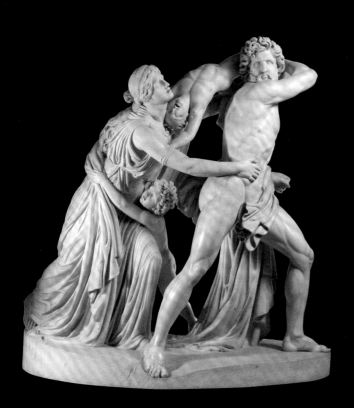

This sculpture was a labour of love for John Flaxman (1755–1826), one of the most accomplished sculptors of his time. It was commissioned in Rome by Frederick Augustus Hervey, 4th Earl of Bristol (1730–1803), for his house at Ickworth in Suffolk but was seized by Napoleonic troops on its journey to England in 1798. The sculpture took Flaxman more than three years to complete but, unfortunately for the artist, in his enthusiasm for the project, he had struck a poor bargain. He was paid £600 for the piece, but the marble alone had cost him £500. The complex, horrifying and tragic subject, The Fury of Athamas, is little known, but depicts the mythical king Athamas killing his son and derives from a tale in the book of *Metamorphoses* by the Roman writer Ovid (43BC–c.AD18). The sculpture finally made its way to Suffolk in the 1820s, when Hervey's son repurchased it for the original sum of £600.

Ickworth, Suffolk · The Fury of Athamas · *John Flaxman*, RA · *1790–4 · Marble · 220 x 198cm · NT 852233 · ‡ 1956*

Italian souvenir lost and found

This marble figure of a young naked boy posing with his bow and arrow was carved by one of the most celebrated Italian sculptors of his age, Antonio Canova (1757–1822). The son of a stone mason, Canova was an outstandingly talented sculptor who worked principally in marble and won commissions from collectors across Europe, including the Emperor Napoleon (1769–1821). This figure was commissioned directly from the artist by Colonel John Campbell, later Baron Cawdor (1755–1821), when he was travelling in Italy in 1786. The artist and the patron became good friends, and when the sculpture was completed in 1789, Campbell was so delighted with it that he paid more than Canova had originally asked. It was installed in his house in London on a revolving platform so that the skill of the artist could be admired from all angles.

By the 20th century this statue had somehow lost its identity and its attribution to the famous artist. It was sold in 1965 as a French 'marble figure of Apollo' and put on display at Anglesey Abbey as a garden ornament, later reidentified as a famous work by Canova.

Anglesey Abbey, Cambridgeshire · Amorino · *Antonio Canova* · *1788–9* · *Marble* · *141.6 x 52 x 50cm* · *NT 516599*

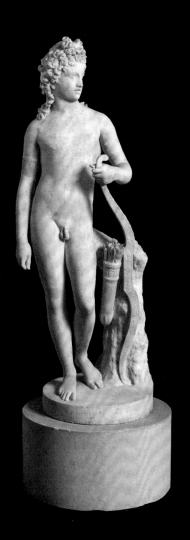

A deceptively messy table

Many useful objects have been discarded on the surface of this unusual side table, including playing cards, coins, a quill pen, a penknife, a pencil, a letter with a red seal, a pair of slender scissors and some pliers, carpet tacks, a folded sheet of music (with an aria from a Belgian opera), a music book and various scraps of paper. However, any guests tempted to tidy the surface or pick up a playing card would soon be surprised, as this unusual table is designed to trick the eye. The table top is simply a very cleverly painted design.

There was a long tradition of this type of representation (known in French as *trompe l'oeil*), and examples can be found dating from classical times onwards. The table was made in France in the late 1700s and painted by Louis-Léopold Boilly (1761–1845), whose father was a furniture-maker. The inclusion of very ordinary objects alongside decorative features, such as a plaster relief depicting children playing with a goat, appears both naturalistic and playful.

Wimpole, Cambridgeshire · Top of a writing table decorated in *trompe l'oeil* · *Before 1793 on a later mahogany support* · *Louis-Léopold Boilly* · *Oil on rosewood parquetry* · *75 x 112cm* · *Signed boillÿ pinx on a rectangular piece of paper, top centre* · NT 206627

Creativity personified

A young woman dressed in an immaculate white dress stands between two figures who can be identified as the personifications of music and painting. The scene depicts the youthful dilemma of the Austro-Swiss artist Angelica Kauffman (1741–1807), undecided about which of her two talents she should pursue. Most unusually for a woman at this period, Kauffman chose to become a painter and went on to establish a successful career in Britain. She was one of the founders of the Royal Academy of Arts and, aware of her own remarkable status as a successful female painter, she made numerous self-portraits to publicise her work. She was in her fifties when she produced the painting shown here and perhaps enjoyed looking back at her youthful self-determination.

Nostell, West Yorkshire · Self-portrait of the Artist Hesitating between the Arts of Music and Painting · *Angelica Kauffman, RA · 1794 · Oil on canvas · 180 x 249cm · Signed and indistinctly dated on the artist's sash: 'Angelica Kauffn Sc. & P. Pinxit, Rome 179(?4)' · NT 960079 · Purchased by private treaty with the aid of a grant from the National Lottery Heritage Fund, 2002*

Portrait of a trusted housekeeper

For more than 40 years, Mary Garnett (1724–1809) served as housekeeper at Kedleston Hall in Derbyshire, and this painting is a fine example of a portrait designed to preserve the link between a person and place as a record for perpetuity. The artist Thomas Barber the elder (c.1768–1843) painted several other portraits of respected household servants for different patrons, and this portrait may have been commissioned by Mary's master, Nathaniel Curzon, 1st Baron Scarsdale (1726–1804).

At this period, the houses of the nobility were regularly opened to curious visitors, and Mary had a reputation as a particularly welcoming and informative guide, with one visitor commenting on her 'obliging and intelligent' nature. She is depicted standing in the Marble Hall at Kedleston, holding a copy of the original printed guidebook available for visitors' use. Dressed in black bonnet and gloves, white gown and dark red robe, she is shown as a respectable, loyal and trusted employee. Mary stayed in service until her death at the age of 85.

Kedleston Hall, Derbyshire · Mrs Mary Garnett in the Marble Hall at Kedleston · *Thomas Barber the elder* · *c.1800* · *Oil on canvas* · *89.5 x 69cm* · *NT 108766* · *Purchased with the aid of a grant from the National Heritage Memorial Fund* · ‡ *1986*

A picture of familial love

In this painting by the eminent Scottish artist Sir Henry Raeburn (1756–1823), three boys – Reginald, Robert and Donald Macdonald – are playing cheerfully in a craggy Scottish landscape. It was probably commissioned by their parents and can be understood as both a record of familial love and a statement of dynastic legacy. By the time the portrait was completed, the boys had lost their father, and Reginald (far right), aged just five, had succeeded to the family title of Chief of Clanranald and 7th of Benbecula.

The scene here marks a shift from earlier periods, when children from elite families were dressed as miniature adults. In this picture the children appear relaxed and are perhaps enacting a childish version of a Highland dance. They wear comfortable clothes known as 'skeleton suits', which were made of two halves that could be buttoned together, allowing for ease of movement.

Upton House, Warwickshire · The Macdonald Children · *Sir Henry Raeburn, RA · c.1798–1800 · Oil on canvas · 143.1 x 113.7cm · NT 446695*

How to win a horse race

Hambletonian is the name of the handsome, prize-winning racehorse depicted here. He stands before us, gleaming with sweat and skittish from his race, the anatomy of his body and the tone of his muscles depicted in impressive detail. The picture is life-sized and impossible to approach without admiring the impressive physique of this sleek and powerful animal. It was painted by George Stubbs (1724–1806), probably the most accomplished animal painter of any generation, right at the end of his career, and this work is considered one of his great masterpieces. It was commissioned by the horse's owner, Sir Henry Vane-Tempest (1771–1813), as an homage to Hambletonian's remarkable ability. The two figures of the stable boy and groom appear upright and stiff alongside the horse. Both look out at the viewer to catch our attention, as if challenging us to recognise the magnificence of their charge.

Mount Stewart, County Down · Hambletonian, Rubbing Down · *George Stubbs, RA* · *1800* · *Oil on canvas* · *209.6 x 367.3cm* · *Inscribed: "Geo: Stubbs 1800"* · *NT 1220985* · *Gifted by Lady Mairi Bury in 1976*

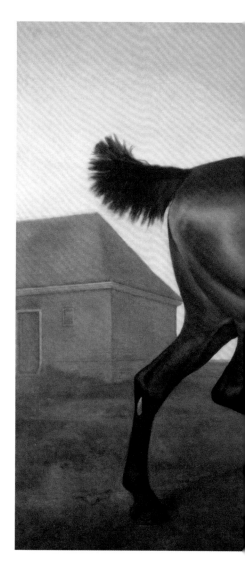

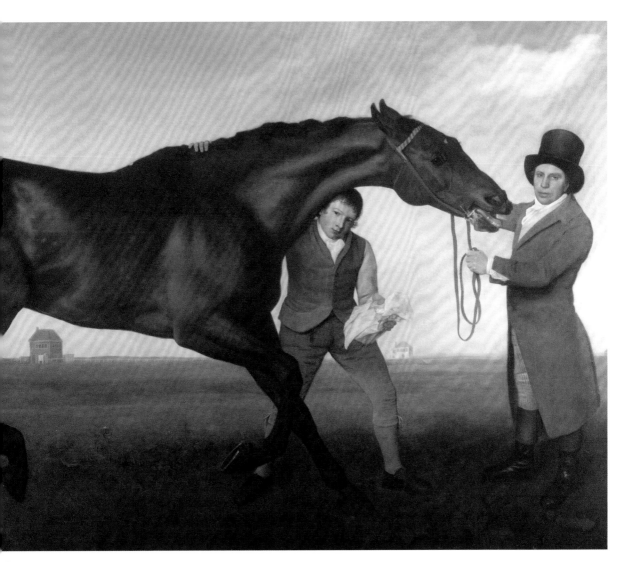

Petworth, West Sussex · A Vision of the Last Judgement ·
*William Blake · 1808 · Pencil, pen and watercolour on paper
· 50.3 x 40cm · NT 486270 · ‡ 1956*

A Vision of the Last Judgement

William Blake (1757–1827) was a visionary artist
and poet whose work was not well known
in his own lifetime. He worked principally in
watercolour, creating powerful and often
complex compositions that provided new visual
interpretations of Christian subjects, classical
myths and literary stories.

This dramatic scene depicts the Last
Judgement, when the 'just and the dammed' are
judged before Christ and rise to heaven or fall
to hell. Blake provided a detailed explanation
of the densely packed action, describing the
ascending figures, on the left, as the righteous
who 'rise thro[ugh] the air with their children &
Families', and those on the right as the wicked
or the 'dammed', who appear 'chained & bound
together fall[ing] thro[ugh] the air … some are
scourged by spirits with flames of fire into the
Abyss of Hell'. This image was commissioned in
1808 by Elizabeth Ilive, Countess of Egremont
(c.1769–1822). She had married George O'Brien
Wyndham, 3rd Earl of Egremont (1751–1837),
in 1801, having already had several children by
him out of wedlock, but the couple separated
in 1803, apparently as a result of the earl's
infidelity. The subject of this painting may
have been considered particularly appropriate,
allowing Elizabeth to focus upon religious
devotion rather than her past sorrow.

A marriage gift with a message

Normally covered by a glass dome, this remarkable Swiss music box consists of a tiny monkey seated in front of a large golden harp and music stand. The monkey is chained to his chair by a gold collar and conducts the music – a melody used by alpine herdsmen to call in their cattle – that is played when the box is wound up. The box is thought to be a wedding present from Thomas, 2nd Lord Berwick (1770–1832), to his wife Sophia Dubochet (1794–1875), and was made in Geneva at a time when the fashion for novel automata was at its height. There was a 24-year age difference between the couple, so while the box may have amused the young bride (who was also provided with harp lessons), it could have been understood, too, as conveying a message about the duty of a new wife to dance to the 'tune' of her husband.

The extravagant lifestyle of the couple eventually led to financial ruin, and they escaped their debts by leaving Attingham for Naples, where Thomas died seven years later.

Attingham Park, Shropshire · Monkey music box automaton · *Moulinie Aine & Cie à Génève (engraved on the steel sheet music)* · *c.1812* · *Ormolu, ebony, ivory, steel, mother-of-pearl, wood and glass* · *22.7 x 14.5 x 10.6cm* · *NT 608416*

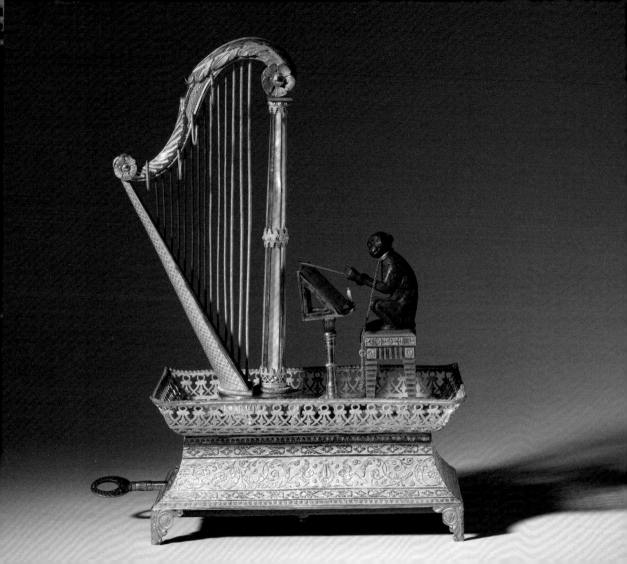

Snoozing like a queen

This sumptuous gilded day bed, upholstered in pale green silk, was originally made for Queen Maria Theresa of Sardinia (1773–1832), as indicated by the recently reidentified gilded letters 'MT'. It was designed for reclining during the day in elegant surroundings, probably in a private boudoir, and was of a type popular for grand interiors in the Napoleonic period. It was probably influenced by the work of Giocondo Albertolli (1742–1839), a Milan-based architect, who developed the designs for furnishing the palaces of Maria Theresa's father, Archduke Ferdinand of Austria-Este (1754–1806).

The bed was brought to Attingham in Shropshire – probably from the Palazzo Tursi, Genoa – during the 1830s by William Noel-Hill, 3rd Lord Berwick (1773–1842), British envoy in Italy, who attended the court of Queen Maria Theresa and her husband King Vittorio Emanuele I of Sardinia (1759–1824). It is not known how Lord Berwick acquired what would have been a personal and intimate piece of royal furniture, but it is possible that it was purchased or offered as settlement of a debt, or was a gift for personal services to the Crown.

Attingham Park, Shropshire · Day bed · *Influenced by the designs of Giocondo Albertolli · c.1814 · Giltwood, walnut, silk · 98 x 204 x 70cm · Armrest has 'MT' monogram surmounted by a coronet of strawberry leaves · NT 608172*

Thomas Bewick

his Mark

Lessons from an ancient storyteller

Aesop's Fables is a compendium of popular stories, most with a moral purpose, written sometime in the 6th century BC. Many versions of the Fables have been published over the centuries, and this illustrated edition of 1818 by the Northumbrian artist, engraver and naturalist Thomas Bewick (1753–1828) also included some stories of his own. By this date he had already published the successful illustrated books *A General History of Quadrupeds* (1790) and *History of British Birds* (1797 & 1804). Bewick's edition of the Fables contains nearly 200 wood engravings, illustrating stories such as 'The Boy Who Cried Wolf' and 'The Boasting Traveller'. The book was a labour of love that he undertook while recovering from a serious illness. It was printed by subscription, and to ensure that it couldn't be copied and cheaply reproduced, each book was verified with an engraving of his thumbprint.

This copy was produced for Bewick's friend and supporter John Trevelyan (1761–1846), who lived at Wallington in Northumberland, and contains a receipt made out to him. The National Trust also cares for Bewick's birthplace, Cherryburn in Northumberland.

Wallington Hall, Northumberland · The Fables of Aesop and Others · *Thomas Bewick · 1818 · Leather and paper · Demy octavo, 22 x 14.3cm · NT 3021359 · Gifted with the property by Sir Charles Philips Trevelyan, 3rd Bt, in 1941*

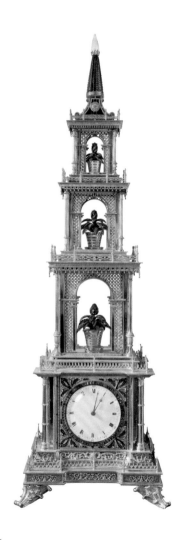

A timely spectacle

If you are fortunate enough to arrive at the right time at Anglesey Abbey in Cambridgeshire, you can see and listen to a spectacle that has delighted guests since the 1800s. This clock, in the shape of a pagoda, not only tells the time but also puts on an automated spectacle every three hours: a tune plays upon 12 bells, while three jewelled pineapple plants on each tier of the pagoda lift from their pots and spin around.

This rare and impressive clock is attributed to the eminent 18th-century jeweller and automaton-maker James Cox (1723–1800), who created other mechanical automata for an international market. We do not know who first owned this remarkable clock, but it is likely to have been a special commission, perhaps for a wealthy foreign collector.

Anglesey Abbey, Cambridgeshire · Pagoda clock ·
*Movement by Henry Borrell (1795–1841) · c.1825 · Automaton
attributed to James Cox · c.1825 · 110 x 36.6 x 30.1cm ·
NT 514745*

Reimagining the shield of the greatest ancient warrior

The exploits of the ancient Greeks were a source of fascination and inspiration in the early 19th century. The jeweller Philip Rundell (1746–1827) commissioned the artist and sculptor John Flaxman (1755–1826) to design the shield of Achilles as described in Homer's *Iliad* (9th century BC). In the myth, Hephaestus, the god of metalworking, formed 'an immense and solid shield' for Achilles, who was half-man, half-god and instrumental in the victory over the Trojans. Flaxman relied upon Alexander Pope's translation of *The Iliad* (1715–20), and at the centre of the shield we see the radiant sun god, Apollo, surrounded by the constellations.

Five of these shields were made in silver gilt between 1819 and 1824, all of them considered masterpieces of Regency silver. One was made for King George IV (1762–1830), and this example, made of solid silver and then gilded, was produced in 1822. It was purchased in the mid-20th century by the collector Huttleston Rogers Broughton, 1st Lord Fairhaven (1896–1966), for his home, Anglesey Abbey in Cambridgeshire.

Anglesey Abbey, Cambridgeshire · Shield of Achilles · *John Flaxman, RA and workshop of Philip Rundell* · *1822* · *Silver gilt* · *97cm diameter* · *NT 516395*

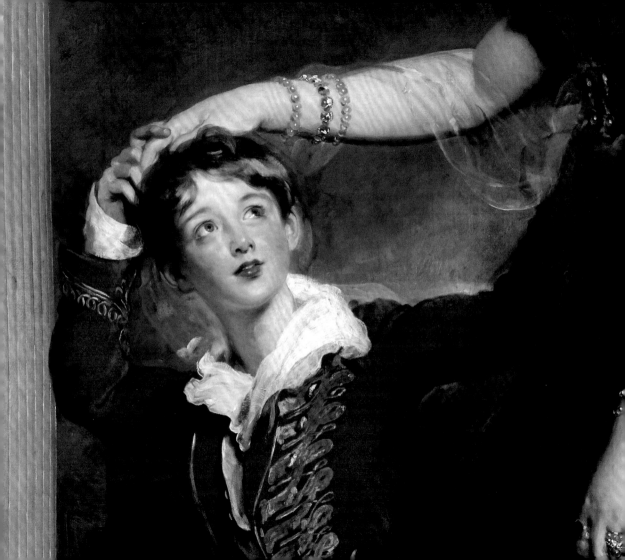

What can a society portrait tell us?

Considered to be one of the most beautiful and talented women of her generation, Frances Anne, Marchioness of Londonderry (1800–65), is shown in this portrait with her playful young son George. What does the portrait tell us about her character and social position? Her husband Charles Stewart, 3rd Marquess of Londonderry (1778–1854), was a key patron of Sir Thomas Lawrence (1769–1830), a fashionable portrait painter of this period. Lawrence spares no effort in depicting Frances as every inch the wealthy, aristocratic heiress and elegant wife and mother by posing her in a sumptuous red-velvet gown pinned with rare jewels. It is significant that she chose to be presented on the threshold of her own house, Wynyard Hall in County Durham, the estate she brought to her marriage. Her evident confidence and poise as she is led up the steps seem to invite viewers into the picture. Later in life she became one of Britain's first female industrialists by taking charge of the family coal-mining business.

Mount Stewart, County Down · Frances Anne, Marchioness of Londonderry, and Her Son, George Henry, Viscount Seaham · *Sir Thomas Lawrence, PRA* · *1827–8* · *Oil on canvas* · *296.5 x 205.5cm* · *NT 1542446* · *‡ 2014*

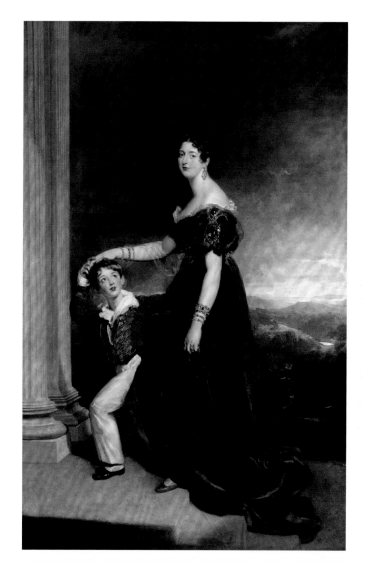

Intimidation and display

Japanese samurai armour is both highly distinctive and powerfully intimidating. With its scale-like metal plates, 'horned' helmet and complete face mask, it was designed to instil fear into enemy forces while providing excellent protection for the wearer.

The armour shown here, however, was not made for military combat but for ceremonial procession. It dates from a peaceful period in the 1830s, when it was necessary for samurai (military lords) to pay homage at the court of the shogun (military dictator). The suit was made in the province of Kaga and bears the signature of a talented master armourer called Kashu ju Munenao, who beautifully decorated it with creatures, including crickets and dragonflies. While the helmet, body and sleeves are matching, the mask and shoulder guards actually come from a different suit. It was purchased for the quality of the craftsmanship by the collector and illustrator Charles Paget Wade (1883–1956) in Wymondham, Norfolk, in the early 20th century and displayed at Snowshill Manor, his house in Gloucestershire, which he gifted to the National Trust in 1951.

Snowshill Manor, Gloucestershire · Japanese samurai armour · *Kashu ju Munenao* · *c.1830* · *Iron, lacquer, braid, silver alloy, rawhide* · *166 x 70 x 27cm* · *NT 1328762*

Experimenting with early photography

In January 1839 something extraordinary happened that would forever influence both science and the visual arts. Two men, working quite separately in France and England, discovered the art of photography. Louis Daguerre (1787–1851) in Paris and some days later William Henry Fox Talbot (1800–77) in London announced their invention. Talbot later refined his process, known as calotype, and made several studies of his own house, Lacock Abbey in Wiltshire.

The calotype process was slow, requiring several minutes of exposure, so it was better suited to architectural scenes than portraiture. Nonetheless, the technique was enthusiastically adopted by amateur photographers, one of whom took this photograph of Ham House in Richmond upon Thames, Surrey in the mid-19th century. It is a rare wax-paper negative that has been scanned so that a virtual 'salted paper' positive can be produced.

Lacock Abbey, Wiltshire · Photograph of Ham House · *Unknown photographer* · *c.1845–55* · *Calotype negative on waxed paper* · *23 x 30cm* · *NT 2900253*

Pioneering female Pre-Raphaelite artist

The painter and poet Elizabeth Eleanor Siddal (1829–62) began her career as a model for Pre-Raphaelite artists and features in some of their best-known paintings. Among them was *Ophelia* by Sir John Everett Millais (1829–96), for which she posed for long periods in a bath of water and caught a severe cold. However, she soon became the pupil of Dante Gabriel Rossetti (1828–82) and established her own artistic career. She subsequently gained the patronage of the influential art critic John Ruskin (1819–1900) and was the only female artist to appear in the 1857 exhibition of Pre-Raphaelites' work in London.

This image, showing a woman in a dark wood reaching out to a ghostly double of herself, appears to relate closely to Siddal's poem 'A Silent Wood', particularly the lines: 'Frozen like a thing of stone / I sit in thy shadow but not alone'. Her expressive, naive style was influenced by her study of medieval manuscripts and Italian art.

Wightwick Manor, West Midlands · The Haunted Wood · *Elizabeth Eleanor Siddal · 1856 · Gouache on paper · 12.3 x 11cm · Signed in the bottom left-hand corner 'E.E.S. /56' · NT 1287904 · Gifted by Helen Dennis (Mrs Guglielmini) in 2001*

A Victorian markswoman

An elegant and fashionably dressed young woman, aiming a gun, stands in a walled garden before a table loaded with pistols and rifles. The title of this painting, *The Crack Shot*, reveals everything the viewer needs to know, but the subject of a markswoman would have been unexpected and potentially alluring. The French artist James Tissot (1836–1902) developed a highly successful career in London, and this portrait is one of his greatest achievements. It dates from 1869, when Tissot was on his second visit to the capital. He settled in England shortly afterwards, becoming part of a society circle that included Edward, Prince of Wales (1841–1910).

The identity of the poised and determined woman in this painting is unknown, but the bearded man seated behind her may be the artist's friend Thomas Gibson Bowles (1842–1922), founder of the then satirical journal *Vanity Fair*. Tissot mainly painted images of glamorous society men and women, and he was particularly attentive to the fall of fabric and decorative trimmings of dress, perhaps because his family were involved in the linen and millinery trade.

Wimpole, Cambridgeshire · The Crack Shot · *James (Jacques) Joseph Tissot · 1869 · Oil on canvas · 67.3 x 46.4cm · NT 207841*

Beauty and utility

The elegant simplicity of this beechwood and rush chair, possibly designed by Philip Webb (1831–1915) for Morris & Co. at the turn of the 20th century, helped this range of furniture to become a commercial success and, ultimately, a design classic. The 'Sussex' range included a variety of items, including armchairs, settees and children's chairs. An advertisement in 1911 for the 'Sussex' chair explained the origins of the design, which was copied, 'with trifling improvements', from a country-style chair found in Sussex. That county had a particularly strong tradition of chair-making, and the design was heavily influenced by the local handmade furniture found in the parlours and halls of farmhouses, parsonages and the homes of professionals.

The chair shown here was part of a set acquired by Lady Mander (1905–88) for Wightwick in 1937, the same year in which she and her husband Geoffrey (1882–1962) donated the house to the National Trust. The set was part of a carefully designed interior that provided a home for their important collection of William Morris designs and Pre-Raphaelite art.

Wightwick Manor, West Midlands · 'Sussex' chair · *Philip Speakman Webb? for Morris, Marshall, Faulkner & Co., later Morris & Co. · In production 1869–1920s · Ebonised beech with rush seat · 70 x 38 x 38cm · NT 1288255.2*

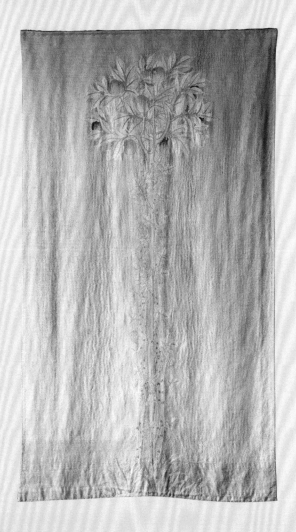

Art and craft

William Morris (1834–96), founder of the Arts and Crafts Movement, was one of the most influential designers of the 19th century, and his decorative schemes, based on natural subjects, have become classics of design culture. This embroidered hanging in coloured silks on linen depicts a simple orange tree, grown as a standard, with bushy foliage, golden oranges and roses climbing up its slender trunk. Although previously thought to have been created for William Morris's home, Red House in Bexleyheath, Kent, it is more likely to be a later adaptation of Morris's design by his daughter Mary, known as May (1862–1938).

The gentle aesthetic of this simple hanging reflects those of the Arts and Crafts Movement, which valued handmade products with a utility of purpose and championed a return to craft traditions. The hanging was used over a door at Bateman's, the East Sussex home of the author Rudyard Kipling (1865–1936), who was close to the Morris circle.

Bateman's, East Sussex · Orange tree embroidery · *Design attributed to May Morris · c.1880–90 · Coloured silks on linen · 178 x 107cm · NT 761662*

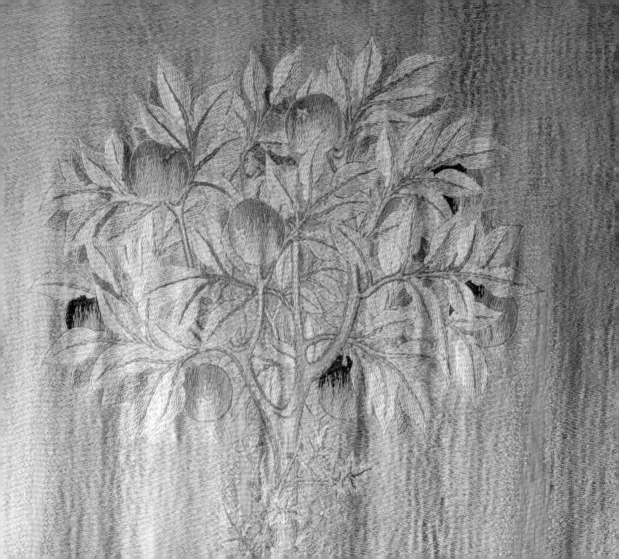

Bold simplicity, colour and vision

William De Morgan (1839–1917), an English artist and ceramic designer working in the late 19th century, was a leading figure in the Arts and Crafts Movement. He experimented with metallic glazes, known as lustre decoration, to create bold, colourful and softly gleaming surfaces on ceramic ware. His work was mainly for decorative use, becoming fashionable in artistic circles, but he did not achieve financial success. He commented that all his life he had tried to 'make beautiful things, and now that I can … nobody wants them'. He eventually took up writing and became a successful novelist, but his reputation as an innovative designer persists to this day.

This large circular dish is inspired by medieval Islamic design and is one of De Morgan's boldest and most compelling works. It depicts an antelope amid abundant stylised foliage, creating a sense of the animal at ease in its natural habitat. It is part of a large collection of De Morgan's work at Wightwick Manor in the West Midlands, the home of Theodore Mander (1853–1900) and his wife Flora (1857–1905).

Wightwick Manor, West Midlands · Dish painted with an antelope at the water's edge against a foliage background · *William Frend De Morgan · c.1872–1907 · Glazed earthenware decorated in ruby copper lustre · 36.5cm diameter · NT 1287188 · Given by Mr J.E. Bullard in 1957*

A sacred Māori pendant

Known as a *hei-tiki* figure, this greenstone pendant is an example of a treasured Māori heirloom that would be passed down through families as a sign of respect. The pendant was brought to England from New Zealand by William Hillier, 4th Earl of Onslow (1853–1911), the owner of Clandon Park. Hillier served as the governor or Crown representative in New Zealand between 1889 and 1892, where his son Huia (1890–1922), was born and named after Ngāti Huia, a Māori sub-tribal grouping. It is possible that this pendant was among a range of gifts presented to Huia Onslow, including a feather cloak and 'greenstone'.

As representations of ancestral humans or spirit forms, *hei-tiki* are suspended from the neck and absorb the *mauri* (life force) of their owners as they are worn. *Hei-tiki* play a key part in Māori death rituals and are placed near the body of the deceased as a spiritual connection between living, dead and past ancestors. This example is one of the few Māori items that survived the fire at Clandon Park in 2014 and represents the enduring colonial connections between the Onslow family and New Zealand.

Clandon Park, Surrey · *Hei-tiki* figure · *Unknown Māori carver · 19th century · Nephrite (pounamu), formerly Haliotis shell (paua) · 15.3 x 7 x 2cm · NT 1441301.1 · ‡ 1984*

The beasts of the forest

Architect, artist and designer Philip Webb (1831–1915) worked closely with his friend William Morris (1834–96), and these four charming animal studies were used in the design of a tapestry known as 'The Forest', made by Morris & Co in 1887. The drawings of the hare and the fox demonstrate Webb's subtle draughtsmanship and eye for detail, while the drawing of the raven perched upon a branch appears keenly observed from life, reflecting Webb's interest in natural history. The lion, with its perfect mane, curled tail and paused stance, appears more naive in style. These drawings, along with another of a peacock, were scaled up to be turned into patterns, known as 'cartoons', which were used by the tapestry makers. The incorporation of spreading leaves, foliage and native wild flowers adds colour and vibrancy to the finished tapestry design (now in the V&A).

Wightwick Manor, West Midlands · The Lion, The Raven, The Hare, The Fox – studies for 'The Forest' tapestry · *Philip Speakman Webb · c.1886 · 58 x 72cm, 66 x 49cm, 87 x 57cm, 89 x 58cm · Pencil and watercolour on paper · The Fox is inscribed upper left: Michaelmas Day 1886 · NT 2900066 · Purchased in 2013 with the support of the Art Fund, Monument Trust, V&A Purchase Grant, the Mander Trust and individual donations*

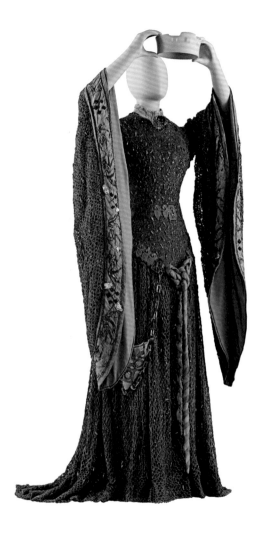

Behold the terrifying vision of Lady Macbeth

This shimmering emerald-green dress, embroidered with iridescent beetle-wing cases, was created for Shakespeare's villainess, Lady Macbeth. It was worn by the famous actress Ellen Terry (1847–1928) at the opening of *Macbeth* at the Lyceum Theatre in London in December 1888.

Designed by Alice Laura Comyns-Carr (1850–1927) and made by Adaline Cort Nettleship (1856–1932), the dress was designed to invoke fear. The addition of beetle-wing cases created the effect of scales, perfecting the terrifying spectacle. The whole outfit, which included a purple velvet cloak, contrasted with Terry's long, dark red hair, which was plaited with gold.

Starring opposite Terry was her long-time acting partner Henry Irving (1838–1905), and the play was one of the theatrical highlights of the 1888 social season. Terry's performance and its powerful visual impact were immortalised the following year in a painting by the artist John Singer Sargent (Tate).

Smallhythe Place, Kent · 'Beetle Wing Dress' for Lady Macbeth · *Alice Laura Comyns-Carr and Adaline Cort Nettleship* · 1888 · *Cotton, silk, lace, beetle-wing cases, glass, metal* · NT 1118839.1

Wightwick Manor, West Midlands · Set of four stained-glass panels · *Charles Eamer Kempe* · *1888* · *Stained glass* · *Each panel 35 x 25cm* · *NT 1288915*

The glass that lights a late Victorian treasury

In 1887, the Wolverhampton paint and varnish manufacturer Theodore Mander (1853–1900) and his wife Flora (1857–1905) designed their house, Wightwick Manor, as an exemplar of the so-called Aesthetic Movement. Its glorious late Victorian interiors remain some of the most complete examples of their type.

Theodore patronised the celebrated stained-glass designer Charles Eamer Kempe (1837–1907), whom he invited to stay at Wightwick, and who created these four glass panels. Kempe was part of the Aesthetic Movement, which celebrated 'art for art's sake', and his inventive designs were influenced by medieval stained glass. Like many Victorian designers, he was interested in the symbolism of flowers, and the main panels depict four blooms, each with a text in Latin or French: a lily, *flos castitatis* (flower of chastity); a strawberry plant with fruit and a snake, *latet anguis in herba* (snake in the grass); a pansy, *pensez à moi* (think of me); and a rose, *nulla rosa sine spina* (no rose without a thorn). Installed at the top of the original main staircase in 1888, the panels filled this part of the house with a diffused glow of coloured light.

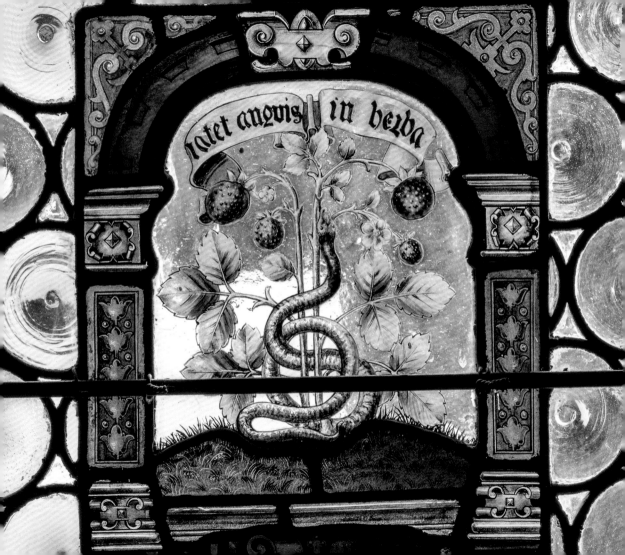
latet anguis in herba

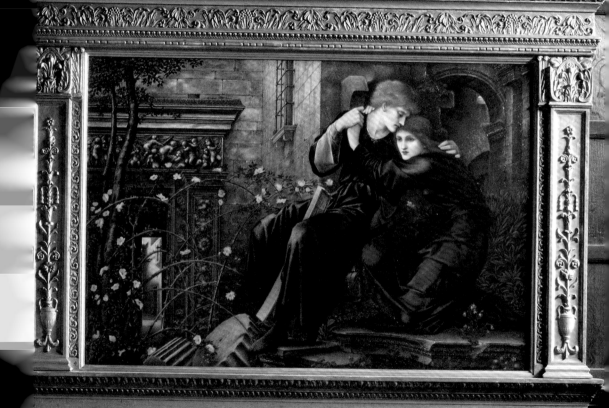

The enduring power of romantic love

Seated among the decaying ruins of a building overgrown with roses are two lovers. The man comforts a woman dressed in a deep shade of blue. The mood is melancholy, almost sombre, and the lovers embrace as if retreating from the world, their love a potent force in an otherwise crumbling civilisation. This is the most important late painting by the Pre-Raphaelite artist Sir Edward Burne-Jones (1833–98) and is based on a watercolour he produced about 20 years previously. The subject was inspired by 'Love Among the Ruins', a poem by Robert Browning (1812 –89). Published in 1855, the poem features two lovers in a ruined city, which allowed the painter to acknowledge the Renaissance artists who had influenced him.

The original composition was painted shortly after the end of Burne-Jones's passionate affair with the Greek artist and sculptor Marie Zambaco (1843–1914), who had become his muse.

Wightwick Manor, West Midlands · Love Among the Ruins · *Sir Edward Burne-Jones, ARA · 1894 · Oil on canvas · 96.5 x 160cm · Signed and dated bottom right: EBJ 1894 · NT 1288953*

The politics of power dressing

This dress tells us a story of our colonial past. It was worn by Mary Curzon (1870–1906), the wife of George Curzon, the Viceroy of India (1859–1925), at a ball in Delhi on 6 January 1903 to mark the coronation of King Edward VII (1841–1910) as Emperor of India. The spectacular and lavish event was full of pageantry and royal ceremony, and was designed to entertain and impress Indian princes and dignitaries, while underlining the power of British rule.

The design of Mary's dress was not only highly fashionable but also subtly political. Made of fabric traditionally worn by Mughal court rulers, it appropriated the motif of a peacock feather (an important Hindu symbol, particularly associated with Lord Krishna and the goddess Saraswati). The intention was perhaps to present a visual sense of continuity, aligning British rule with Indian courts of the past as a statement of dominance. The richly decorated fabric, which includes hundreds of beetle-wing cases, was made by Indian craftsmen, while the dress itself was made in Paris by Jean-Philippe Worth (1856–1926).

Kedleston Hall, Derbyshire · The Peacock Dress ·
*Unknown Indian embroiderers and the House of Worth ·
c.1900–2 · Gold and silver zardozi embroidery with applied
green beetle-wing cases on silk taffeta · NT 107881 · ‡ 1997*

The favourite artist of an art-loving prime minster

In 1949, Sir Winston Churchill (1874–1965) received a gift from his friend and literary agent Emery Reves (1904–81), which he described as 'a very small token of my gratitude for your friendship'. The gift was highly appropriate as Reves knew that Churchill greatly admired the work of the French Impressionist artist Claude Monet (1840–1926).

Monet painted this work on his last visit to London, and it may be the one described in his diary of February 1900, which documents that there was 'an extraordinary fog, completely yellow; I think I did not too bad an impression of it; it's always beautiful.' Appropriately for this gift to Churchill, it presents a view over the River Thames towards Westminster and was painted from Monet's rooms at the Savoy Hotel, one of many different versions he painted. At this date, Churchill was the leader of the Opposition, so Reves concluded his letter with a wish that 'the fog that shrouds Westminster' would lift. The painting remained a treasured possession at Churchill's principal home of Chartwell House in Kent.

Chartwell, Kent · Pont de Londres (Charing Cross Bridge, London) · *Claude Monet* · *1902* · *Oil on canvas* · *64.1 x 90.2cm* · *NT 1102455* · *‡ 1967*

But Nutkin was excessively impertinent
in his manners. He jumped up and
down and shouted —
 "Old Mr B! riddle-me-ree?
 Higgledy, piggledy
 Here we lie,
 Pick'd and plucked
 and put in a pie.
My first is snapping, snarling, growling,
My second's industrious, romping, prowling.
 Higgledy piggledy, here we lie!
 Pick'd and plucked, and put in a pie!"

Now this riddle is as old as the hills;
Mr Brown paid no attention whatever
to Nutkin. But he ate up the mice!

The imaginative world of Beatrix Potter

Beatrix Potter (1866–1943) wrote *The Tale of Squirrel Nutkin* in 1901, while holidaying on the shore of Derwentwater in the Lake District. As with several other of her books, it was originally written in the form of a letter to entertain a child, in this case her friend's daughter Norah Moore, but she soon developed a manuscript copy that closely follows the original letter. The finished book, published in 1903, included 26 illustrations of the jaunty squirrel and began with these playful words: 'This is a Tale about a tail – a tail that belonged to a little red squirrel, and his name was Nutkin.'

The story recounts the adventures of the badly behaved Nutkin, who ends up losing his tail as a result of his foolhardy behaviour and impertinence to an owl called Old Brown. As with all of Potter's books, the story is not just full of delightfully imaginative details about the lives and abilities of animals, but demonstrates her deep understanding of the Lakeland landscape and natural world.

Beatrix Potter Gallery, Cumbria · The Tale of Squirrel Nutkin · *Beatrix Potter* · 1902 · *Ink on paper* · *21 x 14 x 0.5cm* · NT 242203

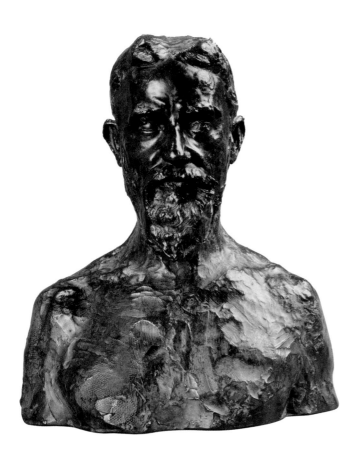

A playwright's reputation captured in bronze

In 1906 the renowned French sculptor Auguste Rodin (1840–1917) was commissioned to make a bust of the playwright, critic and philosopher George Bernard Shaw (1856–1950) by Shaw's wife Charlotte (1857–1943). Two versions were ordered, one in bronze and one in marble. The bronze bust was transferred to the Shaw house, Shaw's Corner in Hertfordshire, in 1945, after the property was gifted to the National Trust.

Shaw had great respect bordering on veneration for Rodin's skill as a sculptor, considering him to be a modern-day Michelangelo. After donating his home to the National Trust, he joked that Rodin's bust would be remembered 1,000 years hence, while its subject would be 'otherwise unknown'. The bronze sculpture accurately depicts Shaw's appearance, while also suggesting the vitality of his presence.

Shaw's Corner, Hertfordshire · George Bernard Shaw · *Auguste Rodin · 1906 · Bronze · 52.1 x 43.2 x 26cm · NT 1274943 · Bequest of George Bernard Shaw, 1950*

Portrait of the first sitting female MP

This portrait depicts the young Nancy Astor (1879–1964) as a society hostess following her marriage in 1906 to the politician Waldorf Astor (1879–1952). Charming, charismatic and often outspoken with a sharp wit, she was elected Member of Parliament for Plymouth Sutton in 1919, becoming the first woman to take her seat in the House of Commons. She and her husband, both American born, lived at Cliveden on the River Thames in Buckinghamshire, and regularly provided lavish entertainment to a wide circle of political and fashionable society.

John Singer Sargent (1856–1925) was a celebrated society painter whose unconventional pictorial style, understanding of light, and skill in capturing likeness and character place him as one of the masters of 20th-century portraiture. His painting of Nancy captures her confidence, playful nature and elegant style, almost like a snapshot in time. It appears to celebrate female independence and vitality, in contrast to a long tradition of more passive and subdued poses for female subjects.

Cliveden, Buckinghamshire · Nancy, Viscountess Astor · *John Singer Sargent · 1908 · Oil on canvas · 153.7 x 102.5cm · NT 766112*

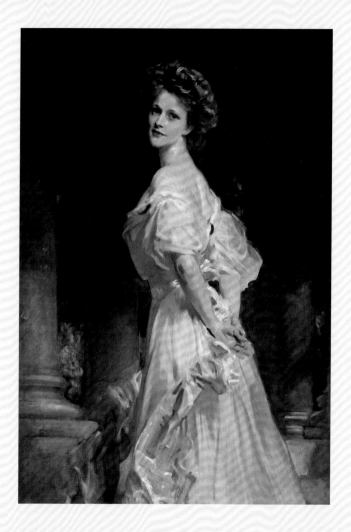

Masterpiece in manuscript

Virginia Woolf (1882–1941) is widely acknowledged to be one of the greatest novelists of the 20th century, and *Orlando* (1928) one of the most remarkable novels. It tells the story of a time-travelling, gender-changing poet over a period of 400 years, and brought her even greater acclaim than she had previously enjoyed.

The bound manuscript, written in purple ink over 286 pages, was sent to Woolf's lover Vita Sackville-West (1892–1962), and the inside cover is simply inscribed 'Vita from Virginia Dec. 6th 1928'. The novel was actually inspired by Vita, her aristocratic family and their family home at Knole in Kent. Although Vita was largely unaware of the novel's narrative before its publication, she later recalled that she read it with 'unparalleled … curiosity', describing the manuscript as 'one of her most treasured possessions'. The page shown here illustrates Woolf's sprawling handwriting with a description of the book: *'A Biography. This is to tell a person['s?] life from the year 1500 to 1928 changing its sex. Taking different aspects of the character in different centuries. The theory being that character goes on underground before we are born & leaves something afterwards also.'*

Knole, Kent · Manuscript of *Orlando* · *Virginia Woolf* · *1928* · *Pen and purple ink on paper, bound in brown calfskin* · *27 x 22cm* · *NT 3072441* · *Presented to the National Trust for Knole in 1962 by Nigel and Benedict Nicolson*

Bloomsbury sisters: artist and sitter

This tender portrait of the emerging writer Virginia Woolf (1882–1941) was painted by her sister, the artist Vanessa Bell (1879–1961). Both women were founder-members of the Bloomsbury Group, a circle of writers and artists who challenged what they considered to be outmoded Victorian conventions of creative endeavour.

At the time of this portrait, Virginia was completing her first novel, *The Voyage Out* (1915), and Vanessa was launching her career as a professional artist. The portrait captures Virginia's thin frame, long aquiline nose, heavy-lidded eyes and slightly resigned expression. Vanessa used this sitting as an opportunity to experiment with a technique she had observed in the portrait *The Girl with Green Eyes* (1908) by the French artist Henri Matisse (1869–1954). She described this as attempting to paint 'in an entirely new way' by considering a 'picture as patches'. The portrait was purchased in 1984 for display at Monk's House, the Sussex home that Virginia bought in 1919 and decorated in a way that expressed her artistic sensibility.

Monk's House, East Sussex · Virginia Woolf · *Vanessa Bell* · *c.1912* · *Oil on panel* · *41 x 31cm* · *NT 768417*

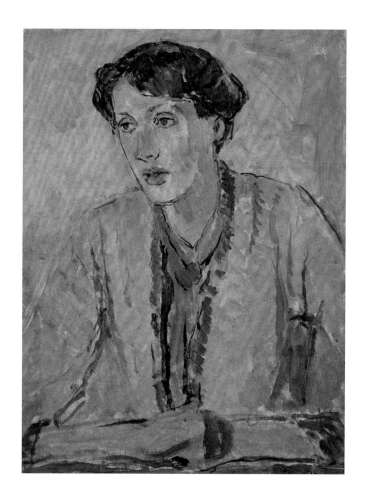

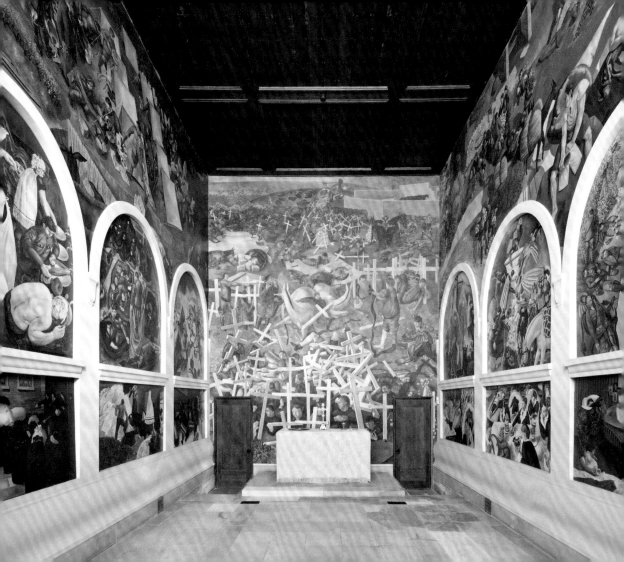

The fabric of life in the First World War

The artist Sir Stanley Spencer (1891–1959) had an unflinching eye for capturing everyday detail and instilling it with meaning. His commission for Sandham Memorial Chapel, one of the greatest painted schemes of 20th-century British art, is utterly remarkable. Spencer served in the First World War as a medical orderly outside Bristol, and then on the Macedonian front, and later drew on his experiences to create this masterpiece. The paintings were commissioned by John Louis Behrend (1881–1972) and his wife Mary (1884–1977) as a memorial to Mary's brother Henry 'Hal' Sandham (1876–1920), who had also served in Macedonia and died of an illness after the war.

Many of the paintings depict ordinary scenes, such as hospital interiors, the wounded arriving by bus, an inspection of kit, and tasks such as cleaning, preparing food, sorting laundry and filling tea urns. One painting, *Map Reading*, depicts an officer on horseback consulting a map with Macedonian place names while soldiers pick berries. The simplicity and banal nature of these subjects, showing both military personnel and civilians, provided a type of antidote to the remembered horrors of war. The chapel was given to the Trust in 1947 by the original patrons.

Sandham Memorial Chapel, Hampshire · Decorative scheme for the Sandham Memorial Chapel · *Sir Stanley Spencer, RA · 1927–32 · Oil on canvas · Eight round-arched canvases approx. 213 x 185cm · Eight predella canvases approx. 105 x 185cm · Three other canvases of various dimensions attached to the wall · NT 790176–94*

A fantasy Welsh landscape

This ambitious and fantastical mural, over 17.5 metres long, was designed as an imaginary view from the windows of Plas Newydd House in Wales, the country seat of Charles Paget, 6th Marquess of Anglesey (1885–1947). Paget commissioned the work (intended for his recently created dining room) in 1936 from the artist Rex Whistler (1905–44), a master of complex compositions that could deceive the eye. This European fantasy landscape encourages us to think we are standing at the edge of the sea on a paved promenade looking onto a stone jetty. In the distance is an impressive coastal town featuring Roman and baroque architecture, along with identifiable British buildings that unfold in dizzying urban

confusion, all backed by the mountains of Snowdonia. This playful scene was one of Whistler's great masterpieces, and he included a portrait of himself as a gardener with broom in hand (at the far end of the left-hand arcade).

Plas Newydd, Anglesey · Capriccio of a Mediterranean Seaport with British and Italian Buildings, the Mountains of Snowdonia, and a Self-portrait Wielding a Broom · *Rex Whistler · c.1936–8 · Oil on canvas laid down on plaster · 365.8 x 1767.8cm · NT 1175991*

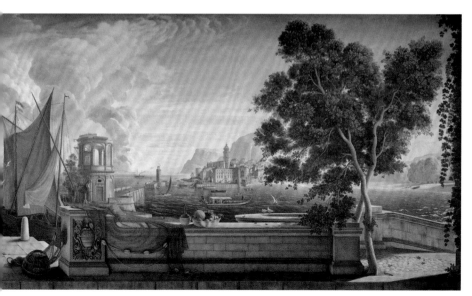

Capturing the 'ghost ship'

In 1939 a thrilling archaeological discovery was made in Suffolk that helped to change our understanding of Anglo-Saxon life and burial practices. The site known as Sutton Hoo, near Woodbridge, contains the multiple burial mounds of an East Anglian royal dynasty, dating from the 7th century AD. A team of archaeologists uncovered the fossil of the ship (caused by the high acidity of the soil) and an astonishing collection of treasures. The finds revealed the wealth, impressive craftsmanship and the wide-ranging connections and trading relationships of the Anglo-Saxon people.

Shortly after the discovery, schoolteachers and amateur photographers Mercie Lack (1894–1985) and Barbara Wagstaff (1895–1973) were given permission to record the fossil of the ship, by which time all the treasure had been removed to the British Museum. Lack described it as a 'kind of ghost ship', and the images she and Wagstaff took provide valuable information about this excavation. The image shown here – from a meticulously annotated photo album – was taken with rare colour slide film and captures some of the archaeologists who undertook the excavation.

Sutton Hoo, Suffolk · Colour photograph album · *Mercie Keer Lack · 1939 · 28 x 23 x 3cm · NT 1940312 · Gifted by Mercie Lack's great-nephew, Andrew Lack, in 2011*

Function, form and ceremony

This small, delicately carved object was made by an artist of the Baule people in Côte d'Ivoire and served as the top of a staff handle or fly-whisk for use by a chieftain or a high-ranking member of the community. The Baule live in an egalitarian agricultural society in the eastern region of Côte d'Ivoire and also in Ghana, and their social and political institutions are guided by matrilineal descent. The carving shares the characteristics of a Baule sculptural mask, displaying an introspective face and wearing a headdress surrounded by fine Akan geometric designs.

If employed as a fly-whisk handle, it would have held long animal hairs that could be swished through the air to discourage insects, and as a prestige object it would also have served an important ceremonial function, conveying the authority and status of its user. It is part of a collection of carved African figures that belonged to Max Mallowan (1904–78) – the second husband of the writer Agatha Christie (1890–1976) – who may have acquired them while serving in North Africa during the Second World War.

Greenway, Devon · Fly-whisk or staff handle · *Unknown Baule artist* · *early 20th century* · Hardwood · *12 x 8.5 x 8cm* · NT 120526.1 · *Given with the contents of Greenway by Rosalind Hicks, Anthony Hicks and Mathew Prichard in 2007*

A gift of friendship

This highly decorated ceremonial shield made in Ethiopia (formerly known as Abyssinia) was a gift from the Crown Prince Asfaw Wossen (1916–97), son of His Majesty Haile Selassie I (1892–1975), to Roger Grey, 10th Earl of Stamford (1896–1976), the owner of Dunham Massey in Cheshire. Lord Stamford was involved in the League of Nations (formed after the First World War to resolve international disputes) and was alarmed by the rise of fascism, particularly in Italy. When Selassie made an address to the League detailing the oppression of Abyssinia at the hands of the Italian government, Lord Stamford invited him to Dunham, and a long friendship ensued.

Ethiopian shields were symbols of power and prestige, and often given as gifts to Western dignitaries. This example (given in 1944) is covered in purple velvet, a colour associated with royalty, decorated in gemstones and delicately worked with gold floral motifs and crosses to reference the Coptic Christian faith. The gift was treasured, and each year on Selassie's birthday the Ethiopian flag is flown at Dunham.

Dunham Massey, Cheshire · Ethiopian ceremonial shield · *20th century* · *Wood, leather, velvet, metalwork, gemstones* · *37.5cm diameter* · *NT 933686*

'Where great ships are built'

This atmospheric image of the monumental dockyards at Birkenhead, featuring the construction of the aircraft carrier HMS *Ark Royal*, was taken in 1950 by the photographer Edward Chambré Hardman (1898–1988). The ship took around five years to build, and the photograph captures her near completion but still surrounded by cranes. The image was published with the title 'Where Great Ships are Built'.

Chambré Hardman set up a photographic studio in Liverpool in the early 1920s. With the help of his wife Margaret it went on to become a thriving business, specialising in both studio and street photography. He was a master at manipulating images in the darkroom, and this image has been reworked to remove debris, retone the colour and fill in the young boy's sock, which had slipped down. These measures helped to reduce distractions and increase the sense of scale, drama and majesty of the ship itself. The photograph is part of a large and outstanding collection, and Chambré Hardman's studio and home at 59 Rodney Street in the centre of Liverpool are owned and run by the National Trust.

The Hardmans' House, Liverpool · The Birth of the 'Ark Royal' · *Edward Chambré Hardman · 1950 · Bromide print · 29.2 x 36.5 cm · NT 967084*

Utility and simplicity

This simple and stylish magazine table, one of only a few variants made, reflects the whole design of the house known as The Homewood, created by the architect Patrick Gwynne (1913–2003) for his parents in 1938. Gwynne was an experimental pioneer of 20th-century modernism, who principally designed homes and interiors.

The Homewood was a house raised upon stilts, which created a light-filled setting in which to appreciate the garden views and carefully placed furniture. Having been furnished by the architect over a 60-year period, the interior is not a monument to 1930s modernism; instead it reflects his search for functional and elegantly simple design. This table dates from the 1960s and is made from American walnut and painted steel with brass supporting legs. The top is covered in brown plastic leathercloth, a choice made in preference to pigskin leather, which was considered too impractical for everyday use. This simple style, which was partly inspired by contemporary European and North American design principles, became a classic and remains popular in variations of flatpack furniture today.

The Homewood, Surrey · Magazine table · *(Alban)*
*Patrick Gwynne (designer) · 1960–9 · American walnut,
leathercloth, brass, painted steel · 39 x 51 x 91cm · NT 864327*

Art of expressive form

Dame Barbara Hepworth (1903–75) was one of the greatest sculptors of the 20th century. Her distinctive and iconic work has not only stood the test of time but also proved highly influential in the world of design and architecture. This sculpture was bought by the diplomat and art collector Sir George Labouchere (1905–99) and displayed within his collection at Dudmaston in Shropshire, which was gifted to the National Trust in 1994.

The power of Hepworth's work was its simplicity, suggesting a new aesthetic sensibility or appreciation of physical forms. Her work was often placed in different settings, both urban spaces and natural or ornamental landscapes as well as in the confines of a gallery, where it would take on different meanings. Hepworth's career spanned from the 1930s until her death, and she worked in stone, wood, bronze and other metals. By casting in metal, she could explore different forms and make multiple versions to meet a popular international demand for her work.

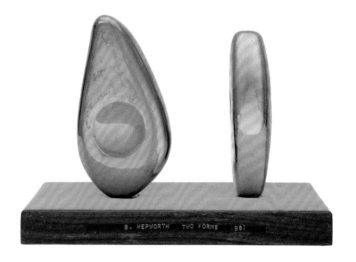

Dudmaston, Shropshire · Two Forms (Orkney) · *Dame Barbara Hepworth · 1967 · Polished bronze and wood · 19.5 x 29 x 20cm · Engraved on a small plaque attached to the base: 'Barbara Hepworth 1967 9/9 MS' · NT 814369*

National Trust timeline

1884 The idea of the National Trust is born when Octavia Hill, one of the Trust's founders, is asked to help preserve Sayes Court garden in south-east London.

1893 Canon Hardwicke Rawnsley learns of the sale of two Lake District landmarks, Lodore Falls and Grasmere Island. This sale accelerates the formation of the Trust as a property-holding body.

1895 Within a few weeks of the National Trust being registered under the Companies Act, it is given its first property: 5 acres (3 hectares) of clifftop at Dinas Oleu in Wales.

1896 The National Trust buys its first building, Alfriston Clergy House in Sussex, for £10.

1899 The Trust acquires its first nature reserve with the purchase of 2 acres (8,000sq m) of Wicken Fen near Cambridge.

1902 A nationwide campaign is launched to raise funds for the purchase of Brandelhow on Derwentwater. The many contributors to the appeal include Princess Louise, daughter of Queen Victoria, and factory workers in the Midlands.

1907 The National Trust Act 1907 gives the Trust the status of a statutory corporation.

1909 The National Trust purchases its first ancient monument, White Barrow on Salisbury Plain. It is the first piece of land the Trust acquires solely in the interests of archaeological conservation.

1912 Blakeney Point in Norfolk is acquired for its value as a coastal nature reserve.

1923 Great Gable, a peak in the Lake District, is presented to the National Trust by the Fell and Rock Climbing Club as a memorial to members who lost their lives in the First World War.

1927 Following a national appeal, the Trust purchases more than 1,400 acres (560 hectares) of farmland around Stonehenge in Wiltshire.

1929 Beatrix Potter uses the income from her children's books to support the National Trust's work in the Lake District. As a result, the 4,050-acre (1,619-hectare) Monk Coniston Estate, near Coniston Water, is acquired.

1934 West Wycombe in Buckinghamshire becomes the first village under National Trust protection.

1934 At the Annual General Meeting, Philip Kerr, 11th Marquess of Lothian, owner of a number of country houses and estates,

Beatrix Potter, one of the National Trust's biggest benefactors, pictured at the Keswick Show in 1935.

a National Trust emblem that will be easily recognised by the public. The result is the now well-known omega symbol with oak leaves designed by the wood-carver and sculptor Joseph Armitage. The emblem starts to appear on signs at National Trust properties from 1936.

1936 Author and architectural historian James Lees-Milne is appointed secretary of the Country Houses Committee of the National Trust. He is instrumental in the first large-scale transfer of country houses from private ownership to the Trust and continues to be actively involved in it until 1973.

1937 The National Trust Act 1937 allows the Trust to accept the gift of country houses, with endowments in land or capital, in lieu of death duties.

1938 The Trust opens Clouds Hill, former home of the soldier and writer T.E. Lawrence, to the public. The first guidebook was written by Lawrence's friend and biographer Captain Basil Liddell Hart.

1939 The gift of Quarry Bank Mill and Styal Estate in Cheshire marks the beginning of the Trust's involvement in industrial heritage.

1940 Following the fall of France to German occupation, the grounds of Osterley Park, Middlesex, are converted to a training

warns of the perils facing country houses, and urges the National Trust to set up a scheme to protect them.

1935 A board of judges is set up under the chairmanship of the Rt. Hon. William Ormsby Gore and entrusted with selecting

school for the first members of the Local Defence Volunteers (later the Home Guard). Lord Lothian leaves his Jacobean house, Blickling Hall in Norfolk, to the Trust.

1945 The National Trust celebrates its golden jubilee as the Second World War finally comes to an end. It now owns 112,000 acres (45,000 hectares) of land and 93 historic buildings, and has 7,850 members.

1946 The National Land Fund is established by Hugh Dalton, the Chancellor of the Exchequer, as a memorial to those killed in the Second World War. Many great country houses are subsequently transferred to the Trust with assistance from this fund, beginning with Cotehele House in Cornwall.

The Trust acquires Chartwell in Kent, home of Sir Winston Churchill.

1948 The Trust joins forces with the Royal Horticultural Society to launch the National Garden Scheme, which encourages and funds the acquisition of outstanding gardens. The first to be acquired, in that same year, is the famous garden at Hidcote in Gloucestershire, which contains plants collected from all over the world by Major Lawrence Johnston. Sir Lyonel Tollemache and his son Cecil give the 17th-century Ham House, near Richmond upon Thames, to the Trust.

1951 Penrhyn Castle, Gwynedd, along with 40,000 acres (16,000 hectares) of land, is accepted by the Treasury in lieu of death duties. It subsequently passes into the care of the National Trust and is opened to the public. Due to its previous owner's bitter dispute with miners during the Great Penrhyn Quarry Strike of 1900–3 and the privations that resulted, some in the local community still refuse to visit it.

1953 Nostell in West Yorkshire is given to the National Trust by the trustees of the estate and Rowland Winn, 3rd Baron St Oswald. The property houses a large collection of Chippendale furniture.

Members of the Home Guard training in the grounds of Osterley Park during the Second World War in July 1940.

1954 Francis St Aubyn, 3rd Lord St Levan, gives most of St Michael's Mount, Cornwall, to the National Trust with a generous endowment fund for its upkeep.

1956 Part of the collection of Petworth House, West Sussex, is accepted in lieu of inheritance tax by HM Government and allocated to the National Trust – the first time a collection has been accepted in lieu of tax.

1957 James de Rothschild leaves Waddesdon Manor in Buckinghamshire to the National Trust, including a large part of its collections and an area of garden. It opens to the public two years later.

1958 Hardwick Hall, Derbyshire, and its contents, many dating back to the time of its first owner, Elizabeth Talbot, Countess of Shrewsbury, are accepted by HM Government in lieu of inheritance tax and allocated to the National Trust.

1961 Dyrham Park in Gloucestershire is opened to the public. A fine example of Baroque architecture set in ancient deer park, it was built for the colonial administrator William Blathwayt in the late 17th century.

1965 The Neptune Campaign is launched with the aim of acquiring unspoilt coastline that might be at risk. Today the National Trust cares for more than 780 miles of coast around the UK.

James Lees-Milne photographed at 42 Queen Anne's Gate, London, in 1950.

1967 The Trust's first Acorn Camps (later renamed Working Holidays for Young People) are held to assist with projects on the Stratford-upon-Avon canal.

1974 The Royal Oak Foundation is incorporated in New York State with the aim of raising funds for and generating awareness of the Trust in the USA. To date, the foundation has raised and granted more than $12 million to support the Trust's work.

1975 Trust membership reaches 500,000.
The Fox Talbot Museum opens in the village of Lacock, Wiltshire. It tells the story of the birth of photography and celebrates the crucial role of the Victorian polymath William Henry Fox Talbot.

1976 The 10th Earl of Stamford leaves Dunham Massey, Cheshire, to the National Trust. The formal park is one of the finest in northern England.
Mount Stewart in County Down, Northern Ireland, is given to the National Trust by Lady Mairi Bury, following the example of her mother, Lady Londonderry, who had presented the gardens to the Trust in the year of her death. It opens to the public the following year.

1977 Cragside in Northumberland is acquired. The house was one of the most technologically advanced of the Victorian age and the first home in the world to be lit by hydroelectricity.

1978 The Trust purchases the Crown Bar (or Crown Liquor Saloon) in Belfast, an outstanding example of a Victorian gin palace, which remains open as a working public house to the present day.

1979 Wimpole Hall in Cambridgeshire is declared open to the public at a ceremony attended by Her Majesty Queen Elizabeth The Queen Mother.

The Giant's Causeway is among the first UK sites added to the UNESCO World Heritage List in 1986.

1981 Membership reaches the 1 million mark.

1982 Kingston Lacy and Corfe Castle, both in Dorset, are bequeathed to the National Trust following the death of Henry John Ralph Bankes, Lord High Admiral of Purbeck.
A sculpture-conservation workshop is established at Cliveden, Buckinghamshire, through the generosity of Mr Henman and the Kensington and Chelsea Association of the Trust.

1984 *The National Trust Manual of Housekeeping* is first published. Alongside practical guidance on care and repair, the manual and its subsequent editions address how

to balance the conservation of historic interiors with increased public access.

1985 Calke Abbey, Derbyshire, its contents and estate are transferred to the National Trust with the assistance of grants from the National Heritage Memorial Fund and English Heritage, and donations from the Harpur-Crewe Estate, an anonymous donor and a public appeal. As part of this transfer, the collection at Calke Abbey is accepted by HM Government in lieu of inheritance tax and allocated to the Trust.

1986 The Giant's Causeway and Causeway Coast, Studley Royal Park (including the ruins of Fountains Abbey), plus Stonehenge and Avebury are among the first UK sites to be added to the UNESCO World Heritage List. Reversing a decision to turn Sutton House in Hackney, London (owned since 1936), into flats, the Trust elects instead to devote it to cultural and educational uses for the benefit of the local community.

1987 Hurricane-force winds damage gardens, parks and woodland across the UK. The garden at Nymans, West Sussex, loses 80 per cent of its mature trees in a matter of hours.

1988 Castle Coole, in County Fermanagh, Northern Ireland, is reopened following a phased programme of repair costing £13 million.

1989 Fire engulfs Uppark House in West Sussex, leading the Trust to carry out its largest and most complex restoration project up to that date. The house eventually reopens to the public in 1995. Stowe Landscape Garden in Buckinghamshire passes into National Trust ownership.

1990 The Snowdonia Appeal is launched by the actor Sir Anthony Hopkins. The Lake District appeal, begun three years earlier, reaches its target of £2 million.

1991 In Northern Ireland, 1,300 acres (520 hectares) of the Mountains of Mourne are purchased, including the highest peak, Slieve Donard (850m).

1994 The Trust acquires 2 Willow Road in Hampstead, north London, a Modernist house designed by the architect Ernö Goldfinger in 1938.

1995 The National Trust celebrates its centenary with a service at St Paul's Cathedral. During its first 100 years the Trust has become the guardian of 580,000 acres (232,000 hectares) of countryside in England, Wales and Northern Ireland, 545 miles of coast; 230 historic houses and 130 important gardens.

1997 The Trust acquires 20 Forthlin Road – the family home of Paul McCartney in Allerton, Liverpool – a typical example of a 1950s council house.

1998 Sutton Hoo, Suffolk, is given to the National Trust. It is the site of a highly significant Anglo-Saxon ship burial, uncovered in 1939.

2000 The Trust acquires Greenway in Devon, once the holiday home of Agatha Christie and her family. Christie described it as 'the loveliest place in the world'.

2002 Tyntesfield, a Victorian Gothic Revival country house near Bristol, is put up for sale. Within 100 days, the National Trust raises £3 million from more than 50,000 individual donors and secures a grant of £17.5 million from the National Heritage Memorial Fund, allowing the house to be purchased and opened to the public.

2003 The National Trust purchases Red House in Bexleyheath, Kent, the house commissioned by Arts and Crafts designer William Morris, a friend and supporter of Octavia Hill.

2004 The Birmingham Conservation Trust works alongside the National Trust to raise £1.9 million to buy and restore the Birmingham Back to Backs, a group of tightly packed houses built around a communal courtyard. They are the last of their kind in Birmingham and recall the 19th-century slums that once housed much of the city's population.

2005 The Trust moves to a new central office, Heelis in Swindon, bringing staff from four separate offices under one roof for the first time. It was named after one of the Trust's biggest benefactors, Mrs William Heelis, otherwise known as Beatrix Potter, the author of the much-loved children's books.

2007 The International National Trusts Organisation (INTO) is formally established at the 12th International Conference of National Trusts in New Delhi. Its mission is to 'promote the conservation and enhancement of the heritage of all nations for the benefit of the people of the world and future generations'.

2008 The total number of National Trust volunteers, donating what Octavia Hill called 'gifts of time', exceeds 50,000.

2009 The National Trust launches its contemporary arts programme, Trust New Art. Since then, the programme has involved collaborations with more than 200 artists to create new work inspired by the Trust's properties.
Following a massive appeal that raised more than £3 million from thousands of

The National Trust at Bristol Pride in 2017.

people, charitable trusts and companies across the country, Seaton Delaval Hall in Northumberland is saved for the nation.

2010 The Kenyan-born poet, novelist and civil servant Khadambi Asalache leaves his London house, 575 Wandsworth Road, to the Trust. Behind the property's simple Georgian façade, the interior is a fusion of Islamic, African and English influences.

2015 A large fire at Clandon Park House in Surrey leaves much of the 18th-century Palladian mansion as a brick shell.

Following a design competition in 2017, plans are announced to bring the house back to life through creative new uses.

2017 Marking 50 years since the partial decriminalisation of homosexuality in the UK, the Trust explores its LGBTQ heritage through a national programme of events called 'Prejudice and Pride'. Membership reaches 5 million.

At last, 124 years after Canon Rawnsley discovered its sale, the Trust acquires Grasmere Island. This means that the Trust now cares for nearly a quarter of the Lake District.

2018 The National Trust's 'Women and Power' programme marks the centenary of the Representation of the People Act. Many properties explore the debates inspired by the struggle for female suffrage across homes, workplaces and communities.

2019 'People's Landscapes', a series of events and exhibitions across the National Trust, explores places that have become important symbols of passion and protest.

2020 The National Trust marks its 125th anniversary, with membership close to 6 million.

From March, National Trust properties are closed for much of the year in response to the worldwide Covid-19 pandemic.

Compiled by David Boulting

Gazetteer of featured properties

For full details of every National Trust property, including further information about collections, opening times, events and facilities, please visit the National Trust website (www.nationaltrust.org.uk) and the National Trust Collections website (www.nationaltrustcollections.org.uk).

Anglesey Abbey, Cambridgeshire · Comfortable Jacobean-style home containing rich collections assembled by Huttleston Broughton, 1st Lord Fairhaven. These include furniture, silver, paintings, books, statuary and late 18th- and early 19th-century English and French clocks.

Attingham Park, Shropshire · Palladian house with French Neo-classical interiors and additions by John Nash. The collection includes family portraits (with works by Angelica Kauffman), white and gold Italian furniture, and a large collection of Regency silver by Paul Storr.

Bateman's, East Sussex · The former home of British author Rudyard Kipling with a comprehensive collection of his family's personal belongings, paintings and 17th- and 18th-century furniture.

Bath Assembly Rooms, Somerset · Georgian building designed for public entertainment, including dancing and dining, with richly decorated Neo-classical interiors. The original crystal chandeliers that lit the halls are still in place.

Blickling Hall, Norfolk · Jacobean house containing family portraits, including works by Thomas Gainsborough and Joshua Reynolds. Home of the National Trust's largest and most magnificent library, which contains examples of early Continental printing and illustrated volumes.

Buckland Abbey, Devon · Once owned by Sir Francis Drake, this remodelled Cistercian abbey includes spectacular Elizabethan plasterwork in the hall, oak panelling and a Georgian staircase. Home to a recently identified self-portrait by Rembrandt van Rijn.

Calke Abbey, Derbyshire · Baroque mansion with fine interiors including a Neo-classical dining room. Presented as it was found in the early 1980s, following an era of decline. The collection is an eclectic mix, including local ceramics, taxidermy, family portraits, early 19th-century furniture and a grand state bed with Chinese embroidered silk hangings.

Charlecote Park, Warwickshire · Tudor house remodelled in the 19th century. Contains an important library and collection of family portraits, as well as fine pieces of furniture, ceramics and metalwork purchased at the Fonthill Abbey sale of 1823.

Chartwell, Kent · The principal residence of Winston Churchill from 1924 to 1965. The collection contains Churchillian memorabilia, including paintings, family photographs, books, maps, cigar boxes and velvet siren suits.

Chirk Castle, Wrexham · Medieval castle and home to the Myddelton family for 400 years. The interiors were remodelled between the 17th and 20th century, and the collection contains items as diverse as a Japanese domed lacquer chest, Neo-classical furniture and significant English Civil War firearms.

Claydon House, Buckinghamshire · Built in the 1760s–70s, with Rococo and Neo-classical interiors. Contains remarkable carvings, 18th- and 19th-century furniture, 17th-century costume and a collection of memorabilia relating to the pioneering nurse Florence Nightingale.

Cliveden, Buckinghamshire · A three-storey Italianate villa, home to the Astor family. Now a hotel, the grounds contain sculptures and Roman sarcophagi, while the house has a collection of paintings and 18th-century Brussels tapestries.

Cotehele House, Cornwall · A Tudor house owned by the Edgcumbe family from 1353 to 1947. The collection includes arms and armour, oak furniture, tapestries, beds and hangings, pewter, ceramics and an ancient faceless clock.

Dudmaston, Shropshire · A modest house built c.1695 and altered in the 1800s. It provides a classical setting for a collection of Chinese ceramics and modern and contemporary art, including works by Ben Nicholson, Henry Moore and Barbara Hepworth.

Dunham Massey, Cheshire · An Elizabethan house extensively remodelled in 1732–40 for the 2nd Earl of Warrington. Contains a highly impressive collection of silver, furniture, paintings and books.

Dyrham Park, Gloucestershire · Baroque mansion nestled in an ancient deer park, built by William Blathwayt, Secretary at War to William of Orange. The collection contains delftware, furniture and pictures with a strong Dutch influence.

Erddig, Wrexham · Country house with Neo-classical interiors and fine examples of 18th-century Chinese wallpaper. The large collection contains paintings and photographs of domestic staff, silver, porcelain and important 18th- and 19th-century furniture, including a state bed.

Godolphin House, Cornwall · Tudor mansion set within a medieval garden. The house has become a holiday let, but the collection includes 17th-century furniture and two heraldic helmet crests in the shape of the Godolphin family emblem.

Greenway, Devon · Georgian house that was the holiday home of Agatha Christie, her children and grandchildren. It contains a variety of objects owned by the family, including books, archaeological material and souvenirs of travel.

Ham House, Surrey · A grand Stuart house with outstanding original interiors and collections, including textiles, lacquer furniture and many 17th-century paintings, featuring miniatures by Nicholas Hilliard and Isaac Oliver.

The Hardmans' House, Liverpool · A Georgian terraced house, the former home and studio of the photographer Edward Chambré Hardman. It preserves the family's furniture and personal effects, as well as the original contents of the studio and the photographic collection.

Hardwick Hall, Derbyshire · Impressive 16th-century house built for Elizabeth Talbot, Countess of Shrewsbury, also known as Bess of Hardwick. Spectacular interiors with huge Flemish tapestries, painted wall hangings, inlaid furniture, original portraits and a fine collection of 16th- and 17th-century textiles.

Hill Top and Beatrix Potter Gallery, Cumbria · Hill Top is a small 17th-century farmhouse, bought in 1905 by Beatrix Potter and featured in several of her illustrations. The Gallery, formerly the office of her husband William Heelis, currently displays the National Trust's collection of Beatrix Potter's artwork.

The Homewood, Surrey · A modernist house designed by the architect Patrick Gwynne for his parents. It contains a collection of furniture and fittings also designed by Gwynne and inspired by the Modern Movement.

Ickworth, Suffolk · Neo-classical house with curved frontage and domed rotunda, designed to accommodate a remarkable art collection. Contains paintings by Diego Velázquez and William Hogarth, a significant library and an outstanding collection of 18th-century silver.

Kedleston Hall, Derbyshire · 18th-century Neo-classical house largely designed by the architect Robert Adam. Highlights in the collection include furniture by John Linnell and Robert Adam, family portraits, architectural drawings and the 1st Marquess Curzon's collection of Eastern artefacts.

Kingston Lacy, Dorset · Grand 17th-century house, home to the Bankes family for more than 300 years. The fine collection of paintings includes works by Sir Peter Paul Rubens and Sir Anthony van Dyck, and the house also boasts a magnificent library and the largest private collection of Egyptian artefacts in the UK.

Knightshayes Court, Devon · Gothic Revival house designed by the architect William Burges. Home to the book and art collection of Sir John Heathcoat-Amory, 3rd Bt, it also has important examples of Italian Renaissance earthenware.

Knole, Kent · Tudor archbishop's palace and home of the Sackville family for 400 years. It has an internationally important art collection, including paintings by Thomas Gainsborough and Sir Peter Lely, 17th-century state furniture and the manuscript of Virginia Woolf's novel *Orlando*.

Lacock Abbey, Wiltshire · Unusual 16th-century country house with later Gothic-style alterations built on the foundations of a former nunnery. Its collection includes early photographic experiments by the pioneering William Henry Fox Talbot, early books and manuscripts, and two unusual octagonal stone tables.

Lyme, Cheshire · An Elizabethan house, developed and extended *c.*1725–35. Its collection includes tapestries, clocks and a copy of William Caxton's *Sarum Missal* printed in 1487, the only known substantially complete copy in existence.

Monk's House, East Sussex · Unassuming house owned by Leonard and Virginia Woolf. Its collection includes painted furniture by Vanessa Bell and Duncan Grant, pictures by Bell and Grant and other members of the Bloomsbury Group, and memorabilia such as Virginia Woolf's writing desk.

Montacute House, Somerset · Elizabethan prodigy house built of honey-coloured stone. The collection includes tapestries and a collection of family portraits, as well as an impressive collection of Tudor and early Stuart paintings on loan from the National Portrait Gallery, London.

Mount Stewart, County Down · Built in the early 19th century, the house contains a fine collection of paintings, including portraits by Sir Thomas Lawrence and equestrian subjects, notably *Hambletonian, Rubbing Down* by George Stubbs.

Nostell, West Yorkshire · A Palladian house built on the site of a medieval monastery. It is home to one of the best surviving collections of Chippendale furniture, some 200 oil paintings, including works by Pieter Brueghel the Younger and Angelica Kauffman, and a significant library.

Osterley House, Middlesex · Remodelled by Robert Adam between 1763 and 1780, the house also contains furniture by him, plus fine Gobelins tapestries and objets d'art from across the globe. Among the latter are 17th-century silver, East Asian porcelain and lacquer furniture.

Petworth House, West Sussex · Set within a 'Capability' Brown landscape, this house has one of the greatest picture collections in the National Trust, including works by Anthony van Dyck, William Blake and Titian. It also has a large collection of sculpture, 17th–19th-century furniture and Chinese porcelain.

Plas Newydd, Anglesey · A family home (remodelled in the 19th century and again in the 1930s), with a collection that includes items relating to Henry Paget, 1st Marquess of Anglesey, and the Battle of Waterloo. There are several works by the artist Rex Whistler, including a large mural in the dining room.

Polesden Lacey, Surrey · Regency villa with opulent Edwardian interiors. The collection includes Dutch Old Master paintings and excellent examples of fine silverware, ceramics and maiolica.

Powis Castle, Powys · Medieval castle, remodelled by generations of the Herbert family. It has an important 17th-century state bedroom and apartment, magnificent paintings, sculptures, furniture and tapestries, and a collection of Indian objects owned by Edward Clive, son of 'Clive of India', who married Henrietta Herbert in 1784.

Saltram House, Devon · A Georgian mansion with a saloon and library designed by Robert Adam. The collection includes paintings by Joshua Reynolds and Angelica Kauffman, a magnificent library, fine furniture and an original Adam carpet in the Saloon.

Sandham Memorial Chapel, Hampshire · Commissioned as a memorial to Lieutenant Henry Willoughby Sandham, who died at the end of the Great War. It contains a visionary series of paintings by Stanley Spencer to commemorate the 'forgotten dead' of that conflict.

Seaton Delaval Hall, Northumberland · Grand mansion designed by Sir John Vanbrugh. The collection includes Delaval and Astley family portraits, statues damaged in a fire of 1822, and 18th- and 19th-century furniture and ceramics.

Shaw's Corner, Hertfordshire · Edwardian rectory that was the home of George Bernard Shaw from 1906 to 1950. Shaw's life as an author, critic, wit and political activist is reflected in a diverse collection that includes books, photographs, sculptures and portraits of the man himself.

Shugborough Hall, Staffordshire · Georgian mansion, enlarged in the 1740s, that was home to the Anson family. The collection features landscapes and family portraits ranging in date from the 17th to the 20th century, sculpture and rare porcelain, including some brought from China by Admiral Lord Anson.

Smallhythe Place, Kent · A 16th-century timber-framed farmhouse that was home to the Shakespearean actress Ellen Terry until her death in 1928. Contains an important collection of theatrical costumes, memorabilia and a working library rich in theatrical material.

Snowshill Manor, Gloucestershire · A 16th- and 17th-century country house restored by the architect, collector and illustrator Charles Paget Wade. It contains an enormous and varied collection, including ceramics, model ships, toys, bicycles, Samurai armour and much more.

Springhill, County Londonderry · Manor house built in the 17th century. Its collection includes 18th- and 19th-century family portraits, a historic library and more than 2,000 items of costume and dress.

Stourhead, Wiltshire · A Palladian villa, built and modified by generations of the Hoare family as the centrepiece of a famous landscape garden. Contains significant collections of Thomas Chippendale furniture, and paintings and furnishings collected on the family's grand tours.

Sudbury Hall, Derbyshire · Late 17th-century house with lavish interiors, including fine plasterwork, carvings by Grinling Gibbons and collections relating to the Vernon family, the owners of the property. Also contains the National Trust Museum of Childhood, which includes an array of toys, costumes and childhood items.

Sutton Hoo, Suffolk · The site of 6th- and 7th-century Anglo-Saxon burial mounds, including the famous ship burial excavated in 1939. The collection includes objects related to the excavation and to the landowner Edith Pretty, and replicas of the archaeological finds.

Upton House, Warwickshire · The home of Walter Samuel, 2nd Viscount Bearsted, whose family founded the Shell Oil company. It houses one of the National Trust's most remarkable collections of porcelain and paintings, including works by Hieronymus Bosch and El Greco.

The Vyne, Hampshire · Tudor mansion that includes a chapel with notable contemporary stained glass. Bought in 1653 by the Chute family, it contains a collection of family portraits and miniatures, 17th- and 18th-century furniture and grand-tour souvenirs.

Waddesdon Manor, Buckinghamshire · Built for Baron Ferdinand de Rothschild in the 1870s to display his collections and to entertain. It has one of the world's finest collections of French art, including Sèvres porcelain, 18th-century furniture, and 17th- and 18th-century paintings and tapestries. Managed by the Rothschild Foundation (charitable trust) on behalf of the National Trust.

Wallington Hall, Northumberland · House remodelled in the 18th century. Its collection includes family portraits, 18th- and 19th-century furniture, 18th-century porcelain and a cabinet of curiosities.

Wightwick Manor, West Midlands · Victorian Aesthetic Movement house containing an important collection of Pre-Raphaelite pictures and Arts and Crafts furnishings. Among these are works by the artists Elizabeth Siddal and Edward Burne-Jones, as well as embroidery and metalwork, and silk and wool textiles by Morris & Co.

Wimpole, Cambridgeshire · Mansion with rich 18th-century interiors. The collection includes 18th- and 19th-century conversation pieces, gilded furniture and one of the Trust's largest and most varied libraries, containing more than 6,000 books.

Compiled by Katie Knowles

Index

Acknowledgements

The following curators, national specialists and property staff from across the National Trust have contributed research for this book: Richard Ashbourne, Frances Bailey, Kate Bethune, Louisa Brouwer, Juliet Carey, Dominic Chennell, Sophie Chessum, Simon Chesters-Thompson, John Chu, Graeme Clarke, Matthew Constantine, Alison Cooper, Emile de Bruijn, Fridy Duterloo-Morgan, Jane Eade, Shannon Fraser, Jane Gallagher, Rupert Goulding, Elizabeth Green, Shannon Hogan, Dawn Hoskin, Laura Howarth, Nelleke IJssennagger-Van der Pluijm, Saraid Jones, Maria Jordan, Sarah Kay, Christo Kefalas, Oonagh Kennedy, Jerzy Kierkuc-Bielinski, Katie Knowles, Carien Kremer, Yvonne Lewis, Andrew Loukes, Alice McEwan, Andrew Morrison, Stephen Ponder, Lucy Porten, Tim Pye, Julie Reynolds, George Roberts, Kathryn Roberts, James Rothwell, Christopher Rowell, Alice Rylance-Watson, Gareth Sandham, Pippa Shirley, Emma Slocombe, Hannah Squire, Nino Strachey, Alice Strickland, Richard Swinscoe, David Taylor, Katie Taylor, Nicola Thwaite, Catherine Troiano, Rebecca Wallis, Roger Watson, Megan Wheeler, Barbara Wood and Chloe Woodrow and the Ickworth Research team.

Sincere thanks are also due to the staff and volunteer specialists whose ideas, advice and object nominations have informed and shaped this book.

The complex task of co-ordinating the new photography for this publication was undertaken by Chris Lacey, Adele Jordan and James Dobson in the National Trust Images team. We gratefully acknowledge their contribution, and that of the photographer David Brunetti, who travelled to properties across England and Wales to photograph many of the objects.

We would also like to thank photographers Andreas von Einsiedel, Bryan Rutledge, John Millar and Paul Highnam, and the property teams for providing access. We are grateful to conservator Zenzie Tinker for facilitating photography of the 'Beetle Wing Dress' at Smallhythe Place; Helen McAneney, the costume curator at Springhill, for her help in mounting the court mantua dress there; and Jeremy Warren for his detailed assessment of the cat sculpture at Powis Castle.

Sincere and heartfelt thanks are also extended to Christopher Tinker, the National Trust's publisher for curatorial content, who brilliantly oversaw the editing, design and production of this book; Katie Knowles, who contributed the gazetteer and also managed the whole project with excellent attention to detail and calm professionalism with assistance from Stephanie Gullen; and David Boulting, for his help in drafting the timeline and for additional proofreading. Thanks are also due to Sally-Anne Huxtable and James Rothwell for kindly reading a first draft of the whole book and providing excellent comments and amendments, and to Corinne Fowler and Raj Pal for their comments on individual entries. We are also grateful to Peter Dawson of Grade Design and Matthew Young for their excellent design work; Patricia Burgess, who meticulously copy-edited the text; Helen Armitage, who proofread the book with great care; Susannah Stone, for her help in clearing image rights; and Christopher Phipps for his index.

The National Trust gratefully acknowledges a generous bequest from the late Mr and Mrs Kenneth Levy that has supported the cost of preparing this book through the Trust's Cultural Heritage Publishing programme.

Picture credits

Pages 2, 4, 8, 16, 17, 18–19, 21, 23, 26 (and cover), 28, 36, 37, 38, 39, 40, 41, 51, 53, 84, 85 (and cover), 88, 90, 91, 96, 97, 100, 102, 103, 107, 110, 111, 116 (and cover), 117, 120, 122, 123 (and cover), 130, 131, 133 (and cover), 134, 135, 140, 153, 154, 155 (and cover), 162, 163, 169, 176, 177, 182, 183, 202 (and cover) © National Trust Images/David Brunetti • 6, 24, 25, 56, 57, 69, 76, 101, 113, 124 (bottom), 127, 141, 142–3, 158, 159 (and cover), 172 (and cover) © National Trust Images/Andreas von Einsiedel • 10 (left and centre) © National Portrait Gallery, London • 10 (right), 27, 52, 94, 95, 148–9, 205, 207 © National Trust Images • 12, 35, 60–1, 68, 71, 118, 119, 167, 174 (both), 175 (both) © National Trust Images/Paul Highnam • 14, 64–5 © National Trust/De Wit • 20 (and cover) © James Fairburn, Oxford Archaeology East • 22 © National Trust Images/Andrew Fetherston • 30, 31 (and cover) © National Trust Images/The National Gallery London • 32, 33, 54–5, 58, 59, 62, 63, 66 (and cover), 67, 72, 77 (and cover), 87, 106, 124 (top), 125, 137, 144–5, 150, 151, 168, 188, 189, 194–5 (all) © National Trust Images/John Hammond • 34, 46, 121, 128, 129 © Waddesdon Image Library • 42–3 © Holy Well Glass • 44 © National Trust Images/James Mortimer • 45 © National Trust Textile Conservation Studio/Jane Smith • 47, 49, 98, 147 © National Trust Images/Angelo Hornak • 48 (and cover), 78, 79, 104, 105, 138, 139 © National Trust Images/Robert Morris • 74, 75, 82, 83, 184 © National Trust Images/Derrick E. Witty • 80 © National Trust Images/Todd-White Art Photography • 86 © National Trust Images/Hamilton Kerr Institute • 92, 93 © National Trust Images/Christopher Hurst • 99 © National Trust Images/Matthew Hollow • 109 © National Trust Images/Dennis Gilbert • 112 (and cover), 160, 161 © National Trust Images/Bryan Rutledge • 115, 199 © National Trust Images/Robert Thrift • 126 © National Trust Images/James Dobson • 146 © National Trust Images/Andrew Patterson • 108, 156, 157 © National Trust Images/John Millar • 164 © National Trust/Roger Watson • 166 © National Trust/Sophia Farley and Claire Reeves • 170, 171 © National Trust Images/Charles Thomas • 173 © National Trust/Helen Rowse • 178, 179 © National Trust Images/Alastair Carew-Cox • 180 © National Trust Images/Paul Raeside • 186, 187 © National Trust/Frederick Warne & Co Archive • 190 © National Trust Images/Chris Lacey • 191 © Estate of Vanessa Bell. All rights reserved, DACS 2020/Image: National Trust • 192, 193 © The Estate of Stanley Spencer/Bridgeman Images/Image: National Trust Images/John Hammond • 196, 197 Original photograph by Mercie Lack. © Trustees of the British Museum. Digital image: National Trust Images/David Brunetti • 198 © National Trust • 201 © National Trust Images/Edward Chambré Hardman Collection • 203 © Bowness. Photo © National Trust Images/David Brunetti • 206 Photographer: Northcliffe Collection/ANL/Shutterstock • 208 © National Trust Images/Joe Cornish • 211 © National Trust Images/Andrew Butler

Published in Great Britain by the National Trust, Heelis,
Kemble Drive, Swindon, Wiltshire SN2 2NA

National Trust Cultural Heritage Publishing

ISBN 978-0-70-780453-8

A CIP catalogue record for this book is available from the British Library.

10 9 8 7 6 5 4 3

Publisher: Christopher Tinker
Project manager: Katie Knowles
Copy-editor: Patricia Burgess
Indexer: Christopher Phipps
Proofreaders: Helen Armitage and David Boulting
Additional picture research: Susannah Stone
Designer: Peter Dawson, www.gradedesign.com
Cover designer: Matthew Young

Colour origination by Dexter Premedia Ltd, London
Printed in Wales by Gomer Press Ltd on FSC-certified paper

Unless otherwise indicated, dimensions are given
in centimetres, height x width x depth

Discover the wealth of our collections – great art and
treasures to see and enjoy throughout England, Wales
and Northern Ireland. Visit the National Trust website:
www.nationaltrust.org.uk/art-and-collections
and the National Trust Collections website:
www.nationaltrustcollections.org.uk

A series of National Trust podcasts based on this book
can be accessed here: www.nationaltrust.org.uk/125pod

‡ Indicates objects accepted in lieu of inheritance tax
by HM Government and allocated to the National Trust

THE AUTHOR

Dr Tarnya Cooper is the Curation and Conservation
Director at the National Trust. She is an expert on Tudor
and Jacobean portraiture, and was formerly Curatorial
Director at the National Portrait Gallery, London.

She has previously taught art history at University
College London, has published numerous books on art
history, and curated exhibitions on portraiture, William
Shakespeare, Elizabeth I, European topography, and
Renaissance and Baroque drawing practices.

The research for this book has been carried out by curators
and specialist researchers across the National Trust.

**ALSO AVAILABLE IN
THIS SERIES**

*100 Paintings from the
Collections of the National Trust*

ISBN 978-0-70-780460-6